American Impressionist and Realist
Paintings and Drawings

from the Collection of
Mr. & Mrs. Raymond J. Horowitz

Introduction by
JOHN K. HOWAT
Curator, Department of
American Paintings and Sculpture

DIANNE H. PILGRIM
Research Consultant, Department of
American Paintings and Sculpture

Catalogue by
DIANNE H. PILGRIM

American Impressionist and Realist Paintings and Drawings

from the Collection of Mr. & Mrs. Raymond J. Horowitz

EXHIBITED AT
THE METROPOLITAN
MUSEUM OF ART
APRIL 19 THROUGH
JUNE 3, 1973

ON THE COVER:

detail from *The Fairy Tale,*

by William Merritt Chase,

no. 6

All color photography by Malcolm Varon, New York.
All black-and-white photographs by William F. Pons,
The Metropolitan Museum of Art,
except: nos. 30, 46 by Malcolm Varon;
no. 24 by Taylor & Dull, Inc., New York.
Designed by Peter Oldenburg
Type set by Finn Typographic Service, Inc.
Printed by Jaylen Offset Lithography Company, Inc.

LIBRARY OF CONGRESS CATALOGING IN PUBLICATION DATA

Pilgrim, Dianne H
 American Impressionist and realist paintings & drawings from the
collection of Mr. and Mrs. Raymond J. Horowitz.

 Includes bibliographies.
 1. Paintings, American — Exhibitions. 2. Drawings, American —
Exhibitions. 3. Impressionism (Art) — United States. 4. Realism in
art. 5. Horowitz, Raymond J. — Art collections. I. New York (City).
Metropolitan Museum of Art. II. Title.

ND 210.5.I4P54 759.13'074'01471 73-4242
ISBN 0-87099-122-1

Foreword

In recent years American painting has enjoyed one of the most lively, interesting, and deserved revivals in the art world. Museums all over the country have rediscovered, dusted off, and added to their American collections, installed them handsomely, and presented them in numerous worthwhile exhibitions, thereby helping to reopen the eyes of Americans to an immensely appealing and important part of their artistic heritage. Although art museums have good reason to be pleased with this activity, it should be remembered that private collectors have often been the pioneer reviving force in American art. They, through their enthusiasm and acumen, have shown the way for the museums. Currently nineteenth-century painting is probably the most restudied and sought-after American art, and the work produced by the last generation of that century and first two decades of the twentieth — impressionist and realist pictures — has begun to receive particular attention. Margaret and Raymond Horowitz, as a result of their perceptive collecting, have been primary leaders of the large and ever-growing group that appreciates the lyric beauty of this work. The Horowitzes have collected examples in painting and drawing of the highest quality, which, brought together in this exhibition, isolate some of the most noticeable characteristics of the art of the period — quietude, simplicity, delicacy, and intimacy. The consistent quality of the Horowitz collection is a remarkable accomplishment and a tribute to the collectors' knowledge and taste. The Metropolitan Museum is grateful to Mr. and Mrs. Horowitz for sharing with the public what they have achieved as collectors of American art.

Thomas Hoving
Director

5

Acknowledgments

The authors wish to express their deep gratitude to Margaret and Raymond Horowitz, whose enthusiasm throughout the production of this book has been inspiring and whose knowledge and carefully kept records have been our greatest source of information. Thanks are also due, for their valuable contributions to the catalogue: Ruth Bowman, Curator, New York University Art Collection; Richard J. Boyle, Curator of Paintings, Cincinnati Art Museum; Grant Holcomb, Assistant Professor, Department of Art, Mount Holyoke College; David McKibbin, Boston Athenaeum; Richard Ormond, Assistant Keeper, National Portrait Gallery, London; and Graham Williford. For their assistance with research problems we are indebted to: Peter Davidson; Linda M. Djerf, Registrar, University Gallery, University of Minnesota, Minneapolis; Charles C. Eldridge, Director, University of Kansas Museum of Art, Lawrence; Linda Ferber, Assistant Curator, Brooklyn Museum; William H. Gerdts, Associate Professor of Art, Brooklyn College; Carolyn Holdtman; James H. Maroney, Sotheby, Parke-Bernet Galleries; Paul F. Rovetti, Director, University of Connecticut Museum of Art, Storrs; Wendy Shadwell; and Susan Solomon, Curator of Painting and Sculpture, Newark Museum. We acknowledge the kind and ready help of the following art dealers and galleries: Gordon Allison, H. V. Allison and Co.; Leon Dalva, Jr., Dalva Brothers, Inc.; Roy Davis, Davis Galleries; Robert Elkon Gallery; Stuart Feld and Jane Richards, Hirschl and Adler Galleries; Ann Fernandez, Librarian, Kennedy Galleries; Michael St. Clair, Babcock Galleries; Robert Schoelkopf, Schoelkopf Gallery; M. R. Schweitzer Gallery; Ira Spanierman; Victor Spark; and Zabriskie Gallery. Our appreciation is also extended to the capable staffs of the Thomas J. Watson Library, The Metropolitan Museum of Art; The Frick Art Reference Library; The New York Public Library; and the Archives of American Art. We are indebted as well to members of the Metropolitan Museum staff whose valuable and willing assistance helped to make the catalogue possible: to Polly Cone, with special thanks for her patience and editorial expertise; to Nathalie Spassky and Louis Sharp, Assistant Curators of American Paintings and Sculpture, for their sound advice, criticism, and support; to Sally Muir and Janet Miller, also of the Department of American Paintings and Sculpture, and to Lauren Shakely, Editorial Assistant, who helped to prepare and organize the manuscript and photographs. Finally, our gratitude goes to James F. Pilgrim for his encouragement and wise counsel.

JKH
DHP

Introduction

Over the past thirteen years Margaret and Raymond Horowitz have assembled, with knowledge and intuition, a cohesive collection that captures the mood of the 1880s through the turn of the century in America. Even though it spans over forty years and includes several painting styles, the collection is unique, for it illustrates the sensibility of the time. Despite the diversity of their styles—impressionism, realism, tonalism—painters of the period were bound together by their interest in similar themes, moods, and compositions and by a common concern with the effects of light and atmosphere. The Horowitz collection affords us a view of what E. P. Richardson termed "quietism," that blend of graciousness, intimacy, and optimism that pervaded the painting of the Gilded Age.

In the last quarter of the nineteenth century, America was entering a new era of industrialization, social reform, and urbanization, but most contemporary artists turned from these radical changes, isolating themselves in a private world of beauty and familiarity. They chose to ignore the reality of urban life and its resulting poverty. Instead, their focus was on friends and family, and their approach to landscape was subjective and personal, a reaction to the naturalistic and panoramic views of the earlier Hudson River School.

In spirit the Horowitz collection is bounded by the birth of the Society of American Artists in 1877, which helped to promote the new subjective approach and a more expansive, painterly technique, and the Armory Show of 1913, which introduced America to European abstraction. The transition from a tradition in painting that was moralistic, anecdotal, and literary to one concerned with visual effects and the evoking of moods began to occur in the 1870s. Germany, which earlier in the 1800s had been the center of study and inspiration for many Americans, lost its place of prominence to France late in the seventies. The French dominance was to be felt in this country well into the twentieth century. Indeed, the majority of artists represented in the Horowitz collection were influenced in the late 1880s and 90s by French impressionism. This influence on the Americans is more apparent in their lightened palette, mood, and choice of subject matter than in the dissolution of form and the juxtaposition of pure colors so characteristic of the French impressionists. The Armory Show shattered, in a symbolic way, this intimate and personal aesthetic mood, just as the war that followed shortly thereafter signaled the end of the private world that had made such a mood possible.

During the first three-quarters of the nineteenth century American painting had enjoyed a period of remarkable development. Building upon an earlier production of simple portraiture and occasional history painting, the American painters of the first half of the century had pioneered in still life, genre, and landscape, areas rela-

tively untried in this country. Among the best known of the innovators were Samuel
Morse, Washington Allston, Thomas Cole, Asher B. Durand, and William Sidney
Mount, whose work comprises the first recognizable American "school." The content
and style of their painting derived substantially from English romantic thought and
Continental (German and Italian) technique, as well as from pragmatic and hope-
ful American perceptions. In 1825 the National Academy of Design was founded in
New York by the young Morse, Durand, Cole, and others as a liberally minded art
school in competition with the conservative and restrictive American Academy.
Fifty years later the National Academy would become as inflexible in its opinions
and as protective of its members as the institution it had replaced.

During the 1870s a new generation of artists, an ever-growing number, demanded
more and better art schools than the United States could provide. Accordingly,
American students left eagerly for Germany (especially Munich), the Netherlands
(The Hague), and Paris. In Germany and Holland the neophytes absorbed the
current revival of interest in seventeenth-century Spanish and Dutch portraiture
and genre painting, both of which were distinguished by their reliance on a broad,
firm brushstroke, dark tonality, and fully developed chiaroscuro. One result of this
revival was the redirection of the artist's attention to the unadorned facts of life
about him, the encouragement of a more painterly realism in the wake of a genera-
tion that thrived on romantic idealism in art.

Munich, in particular, attracted the more adventuresome American artists. The
leaders of this group—Frank Duveneck, William Merritt Chase, John Twachtman,
and Robert Blum—grew up and received their earliest training in Midwestern cities
such as Cincinnati and St. Louis, where there had been a large immigration of
German intellectuals and artists before the Civil War. Not unnaturally, Germany
offered these young men their most alluring prospect for study abroad. In Munich
they learned to apply a dashing technique to otherwise mundane subjects (por-
traiture and landscape) and to exotic ones (gypsies, quaint peasants, soldiers) as
well. The appeal of Munich was short-lived, however, and Duveneck and the others
moved on to northern Italy, where they discovered two things that were to shape
their subsequent work: the sparkling water and skies of Venice and the art of James
Abbott McNeill Whistler. He was among the first to promote a simplified and for-
mal arrangement of color and form in painting. Whistler's dictum "Art for art's
sake" became the aesthetic keynote of the time, and his emphasis on asymmetrical
composition and a decorative treatment of form and color shows the influence of
Japanese prints. Although no other American went to Whistler's abstract extremes,
his legacy to American art was to establish the value of simplified forms and the
evocative power of color. This contributed to a decisive break with the anecdotal
and moralizing quality essential to most previous American painting. In its place,
mood and poetry on canvas and the harmony of subtly related tones were artistic
justification enough.

By late in the 1870s the source of European influence had shifted from Germany

to Paris, although as early as the forties a few Americans had been drawn to France. One of these was William Morris Hunt, who became an ardent admirer and disciple of J. F. Millet, the spiritual leader of the Barbizon school. Southeast of Paris, in the forest of Fontainebleau, Millet and his followers had revolutionized French landscape painting by introducing an informal and intimate view of nature enhanced by a subtle and compelling light.

In 1855 Hunt returned to Boston, which, under his aegis, became the first American city to collect, and eagerly collect, the seemingly radical and awkward works of Millet, Corot, Rousseau, Diaz, Daubigny, and Courbet. In 1866, when Courbet was contending with the leaders of the official art establishment of Paris, a club of Boston artists, led by Hunt, purchased Courbet's richly painted hunting scene The Quarry, his first painting to come to America. When told the news, Courbet said: "What care I for the salon, what care I for honors, when the art students of a new and great country know and appreciate and buy my works?"

An early student and friend of Hunt's was John La Farge. Intensely intelligent, well educated, and articulate, he had studied as a gentlemanly pastime with Thomas Couture in the 1850s in Paris. According to La Farge, "Couture was not pleased at my reasons for study, and complained of there being already too many amateurs. I pleaded my cause successfully, however, and remember arguing the value of the middle man, who would explain and interpret new variations and expressions to a more outside public." For over half a century in New York, La Farge was indeed a "middle man" between the conservative element in this country and the radical developments in French art. His own plein-air landscapes of the 1860s, which anticipated the impressionists in their awareness of transitory light and its effect on color, were little understood, but La Farge did educate American collectors to the appeal of the Barbizon landscapes and Oriental art, particularly Japanese prints.

Young American artists returned from Europe in the 1870s with fresh new ideas and techniques: the rich and painterly brushwork of the Munich school, Whistler's abstraction of form and color, and the intimacy of the Barbizon landscapes. Finding themselves impeded by the unyielding standards of the National Academy of Design, the young men retaliated in 1877 by founding the Society of American Artists, which for the next twenty years would be the most progressive organization of artists in America. The Society established its own art school and held annual exhibitions that successfully competed with those of the Academy. After the Society's first show, in March 1878, Clarence Cook, art critic for the *New York Tribune*, declared: "This exhibition means revolution. Here in this modest room Art in America . . . shuts the door behind her and . . . sets out in earnest to climb the heights."

Even the Society's severest critics considered the new developments necessary to the establishment of a new national art. Daniel Huntington, president of the National Academy, only grudgingly recognized the younger painters. In 1878 he wrote: "The absence [in the Academy] of the new and perhaps stormy element has undoubtedly caused some stagnation and weakened the exhibitions—we need all

the vital forces—unity among ourselves is essential in maintaining our position amidst the overflowing torrent of foreign competition." *Scribner's Monthly,* in a series of articles begun in May 1880, commented: "At present it is quite evident that we are but accumulating and perfecting the material for such a national expression, and even to the taking of so initial a step as this, the destruction of our old canons and standards was necessary."

Another revolution, of far greater consequence, occurred in 1874 in France. A group of French painters defied the official Salon of Paris by organizing its own exhibition. The impressionists, whose membership changed from year to year, held eight shows, the last in 1886. It was from the title of Claude Monet's painting Impression—Sunrise, shown at the first exhibition, that a Paris critic coined the term "impressionism" to distinguish the works of Monet, Degas, Renoir, Pissarro, Cézanne, Sisley, and Berthe Morisot. These painters, though differing in ideas, were concerned in common with the transitory effects of light and atmosphere and the informality and intimate charm of everyday subjects. Some studied optics and color theory and developed a technique of broken, juxtaposed color in an attempt to re-create the changing effects of light. Though their work was considered incomprehensible by many for its seemingly barbaric color and clumsy drawing, their style was, as John Rewald had said, "the culmination of a slow and consistent evolution."

For years American artists resisted the new approach and innovative work of the impressionists. Most Americans in Paris in the late 1870s and the 1880s studied with the academic painters—in the studios of Gérôme and Carolus-Duran or with Boulanger and Lefebvre at the Academy Julian. That atelier was most popular, perhaps because, unlike the Ecole des Beaux-Arts, Julian's required no entrance examination. Further, the Americans tended to be clannish, some never even learning French. Their heroes were Jules Bastien-Lepage and Jules Breton, academic plein-air realists, rather than the radical impressionists.

In the late 1880s, however, Theodore Robinson, Childe Hassam, John Twachtman, and Willard Metcalf, among others, began to paint French-inspired impressionist works. But unlike the French originators, the Americans never fully embraced a system of broken color and dissolution of form. The tendency to pursue the more radical possibilities of impressionism—to move toward extreme technique or explore the phenomena of vision that so involved the impressionists and post-impressionists—never had a strong appeal in this country. It was their shared interests in the everyday world as subject matter, the informal and intimate point of view, and the simple joy of color that drew some Americans to the new movement.

It was not until after 1886, when the French impressionists had disbanded after their last exhibition, that Americans began to emulate the style. However, the United States had been exposed to impressionism through exhibitions and publications. As early as 1879 Manet's Shooting of Maximilian was seen briefly in New York and Boston, and Mary Cassatt exhibited her Opera Box at the Society of American Artists in 1881. The same year Julian Alden Weir, advised by Chase,

bought Manet's Boy with a Sword and Lady with a Parrot for the collector Erwin Davis. In 1883 Boston was host to a *Foreign Exhibition,* which included works by Monet, Pissarro, Renoir, and Sisley, and in 1884 Chase and James C. Beckwith organized the *Bartholdi Pedestal Fund Art Loan Exhibition* in New York, with paintings by Manet and Degas. But it was not until 1886, when an exhibition of 300 Barbizon and impressionist paintings from the Paris dealer Durand-Ruel were brought to New York, that the impressionists received widespread publicity. The critic for the *New York Herald* reportedly thought "that there were too many pictures by cranks, but in spite of all the absurdly mannered and even nonsensical pictures, he found the show extremely interesting."

As early as the mid-eighties John Singer Sargent had become friendly with Monet and, in the period ending in 1890, painted his most French-inspired impressionist landscapes. Although it was his bravura portraits with their painterly realism that influenced most Americans, Sargent's more personal work had its effect as well. His intimate, experimental side, as seen in the Horowitz collection, is demonstrated in the paintings he did when he could escape the confines of his official portraiture. This more relaxed style directly affected the work of Dennis Miller Bunker when the younger man spent the summer of 1888 with Sargent in England.

In 1887 Robinson, Metcalf, and others discovered Giverny, Monet's home. A series of rapid developments followed as the Americans returned to the United States, modified impressionism, and made it their own. In 1889 a sizable group of Robinson's impressionist works was shown at the Society of American Artists. That same year Hassam returned from France a full-fledged convert to the new style. Robinson directed Twachtman toward a lighter palette and more painterly technique, and, in turn, their close friend Weir began to loosen his brushstroke and expand his color range. Chase, whose profound influence spanned a generation, guided late nineteenth-century American painting toward a technique that combined Munich-inspired brushwork with the radiant palette of the French impressionists. In Boston in the 1890s Edmund Tarbell, Frank Benson, and Joseph De Camp were creating light-filled, plein-air canvases and Vermeer-like interiors with women. Tonalism, a particularly American offshoot of impressionism, is exemplified by the works of Thomas Dewing. His color is limited to the light of evening, gray days, or of the interior; the scene is glimpsed through a veil of mist.

The Horowitz collection, rich in fine examples of pastel, illustrates this medium's contribution to an increased awareness of color and reveals the growing love of spontaneity and intimacy that began in the eighties. The revival of pastel in America at the end of the nineteenth century can in large measure be attributed to the influence of Whistler. Blum and Twachtman were with him in Venice in 1880 when he executed a series of pastels, which he proudly showed to his colleagues. The Americans conveyed their enthusiasm for the medium to Chase, and in 1881 or 1882 the Society of Painters in Pastel was founded in New York with Blum as its president. The Society held its first exhibition in 1884, its second in 1888, and annual

shows thereafter. The wispy, sketchy quality characteristic of Whistler's pastels is evident in the work of Blum, Twachtman, Hassam, and Metcalf. Chase, on the other hand, used the medium as he did oils, displaying his facility as a technician and colorist.

As a style, American impressionism lacked the coherence of its French prototype. The Americans shunned theories and experiments and delighted instead in the decorative and surface qualities of the new art. Although their approach was never as radical as that of the French, the American impressionists met with considerable popular resistance at home. The academic point of view—correct drawing, knowledge of anatomy, faithful rendering of form and color, and the proper theme—remained a strong current of thought in this country well into the twentieth century.

By the end of the 1890s impressionism was acceptable to most artists, critics, and collectors. Yet in 1898 a number of impressionists felt compelled to resign from the Society of American Artists and establish their own organization, the Ten American Painters. The men were Hassam, Weir, Twachtman, Metcalf, Dewing, Edward Simmons, Robert Reid, Tarbell, Benson, and De Camp. When Twachtman died in 1902 his place was taken by Chase. These men withdrew from the Society for the same reason that the Society had earlier rebuffed the National Academy of Design: form and tradition had stifled independent thinking. Ironically, the National Academy and the Society of American Artists, growing steadily more conservative, were to merge in 1906.

Another group of artists, contemporary with the Ten American Painters, believed that impressionism had become as academic as any style that preceded it. A new spirit of democracy in the air during the nineties demanded a more realistic presentation of the human condition. Led by Robert Henri, a vital force in progressive art at the turn of the century, The Eight revolted against the sentimentality, genteel vision, and sweet colors of the impressionists. Their attention moved from the lyrical charms of the countryside to the activities of urban life and industry. The Eight were not united stylistically; the poetic tapestries of Maurice Prendergast, the dream worlds of Arthur Davies, and the impressionist landscapes of Ernest Lawson were markedly different from the realism of Henri, John Sloan, George Luks, Everett Shinn, and William Glackens. They concurred, however, in wanting to be free from the tyranny of the academies. In 1907 Luks, Sloan, and Glackens were barred from the annual exhibition at the National Academy of Design. Outraged, Henri retaliated by mounting a counterexhibition. When the show opened at the Macbeth Gallery in 1908, it caused a sensation. Said one critic: "These canvases of Mr. Prendergast look for all the world like an explosion in a color factory." Others complained of some of the artists' "unhealthy, nay even coarse and vulgar point of view." It was mainly this point of view—a focus on urban life and the common man—that separated The Eight and others, like Charles Hawthorne and George Bellows, from the previous generation. Despite its subject matter, their work belongs with

12

that of the impressionists of the late nineteenth century, for it remained informal and painterly in style and optimistic in spirit.

In 1913 the Armory Show, with paintings by Cézanne, Gauguin, Picasso, Matisse, and Duchamp, among others, made a totally unaware public cognizant of the European developments in abstract art and shook the confidence of many American artists. And then, with the outbreak of World War I the artists' illusion of a gentle and private world began finally to collapse.

The Horowitz collection cuts across stylistic considerations, concentrating on the common characteristics of the fin-de-siècle spirit. Indeed, this spirit is the dominant factor among these paintings, overriding stylistic differences that are not strongly delineated. The 1880s through the turn of the century in American art is unlike the same period in France, where stylistic differences were much more distinct. The painters represented here illustrate the subjective and painterly approach to art that developed in this country during the 1870s under the influence of the Munich school, Whistler, and the Barbizon landscapes and was brought to fruition under impressionism. To judge from the pictorial record, the artist's world was a privileged one of leisure, privacy, and optimism, in which his family and friends relaxed in the sunlight or in the intimacy of their homes. Landscape and womanhood were the favorite subjects, but unlike the treatment earlier in the nineteenth century, these did not tell a story or interpret a moral. Everyday experiences and familiar landscapes suggested a mood through the use of color and a reductive and decorative composition. The Americans' confidence and candor, presented in such poetic and genteel terms, supports Lawrence Chisholm's contention in *The Life and Letters of J. Alden Weir* that "a life of quiet harmony represented not a retreat but an ideal."

American Impressionist and Realist
Paintings and Drawings

from the Collection of
Mr. & Mrs. Raymond J. Horowitz

JOHN LA FARGE

1835-1910

La Farge's parents were well-to-do French immigrants, and his childhood was spent in a liberal, intellectual atmosphere, surrounded by the French classics on the bookshelves and European paintings on the walls. By the time he left for Europe in 1856 he had graduated from college and had studied law. Through the introduction of his relatives in France, he moved in and out of the Parisian literary society and art world. He studied briefly in the atelier of Thomas Couture and traveled to Germany, Denmark, and England. It was not until he returned to America, though, that he decided to become a professional artist. In 1859 he settled in Newport, Rhode Island, and worked under the guidance of William Morris Hunt. Many influences bore on his work. He was an ardent admirer of Corot and the Barbizon painters, whose subjective landscapes he had seen in Paris. The richness of Delacroix's color and the chiaroscuro of Rembrandt's etchings had impressed him greatly. He accepted the creed of the Pre-Raphaelites, that everything should be represented exactly as it is seen. The influence of scientific studies of color principles and the two-dimensional patterns and asymmetrical compositions of Japanese prints fascinated him. All these factors contributed to a group of his plein-air landscapes that anticipated the French impressionists in their concern for light and atmosphere and in their color effect. "I wished to apply principles of light and color of which I had learned a little," wrote La Farge. "I wished my studies from nature... to be free from recipes, and to indicate very carefully in every part, the exact time of day and circumstances of light." These unusual paintings from the 1860s were little understood or appreciated at the time. Disappointed, La Farge pursued his interest in color and light through the medium of stained glass. During the 1870s his interest turned to more decorative work, a pursuit of the union of painting, sculpture, and architecture. He became a mural painter, though continuing with his designs for stained glass, and he also wrote and lectured. His early interest in Japanese art (he bought his first Japanese prints in 1863) prompted him to visit Japan in 1886 and the South Seas in 1890. Both these trips were recorded in beautiful series of watercolors that form the most memorable part of La Farge's work.

1 LA FARGE: Wild Roses and Water Lily

Watercolor on paper; 10⅝ x 8⅞ inches (sight).
Unsigned; late 1870s–early 1880s.

During the 1860s there was a new interest in flower painting on both sides of the Atlantic. Under the influence of Ruskin the still life had returned to a natural setting as opposed to the botanical approach and neutral background of previous decades. As early as 1859, at the time he began to paint landscapes, La Farge started a wonderful series of flower still lifes, some in bowls or vases on windowsills or tables, others, particularly the water lily and magnolia, floating in natural pools of water. He searched to describe the soul of the flower, its inner meaning rather than its botanical form. The blooms are surrounded by an atmospheric veil of light and shadow, which makes them seem all the more mysterious. The water lily was his particular favorite. He spoke of its "mysterious appeal such as comes to us from certain arrangements of notes of music." This watercolor belongs to a group which appears to have been done in the late 1870s or 1880s. Wild Roses and Water Lily shows an Oriental influence in its diagonal composition and its feeling of deep space countered by the illusion of an overall flat pattern.

REFERENCES: Cecilia Waern, *John La Farge, Artist and Writer,* London, 1896, ill. opp. p. 26; Royal Cortissoz, "John La Farge," *Outlook,* Nov. 1906, pp. 479–488, ill. p. 487; Royal Cortissoz, *John La Farge: A Memoir and a Study,* New York, 1911, ill. opp. p. 56; Arthur E. Bye, *Pots and Pans, or Studies in Still-Life,* Princeton, N.J., 1921, pp. 194–195; Frank J. Mather, Charles R. Morey, William J. Henderson, *The Pageant of America: The American Spirit in Art,* New Haven, Conn., 1927, ill. p. 72.

EXHIBITED: Durand-Ruel Galleries, New York, 1895, *Catalogue of Works by John La Farge,* no. 221; Wildenstein & Co., New York, 1931, *Loan Exhibition of Paintings by John La Farge and His Descendants,* no. 30; Metropolitan Museum, 1936, *An Exhibition of the Work of John La Farge,* no. 38; Cleveland Museum of Art, 1937, *Exhibition of American Painting from 1860 until Today,* no. 122; Kennedy Galleries, New York, 1971, *American Masters, 18th to 20th Centuries,* no. 39, ill. p. 40.

EX COLL.: Mr. and Mrs. M. Bernard Philipp; [Kennedy Galleries, 1971].

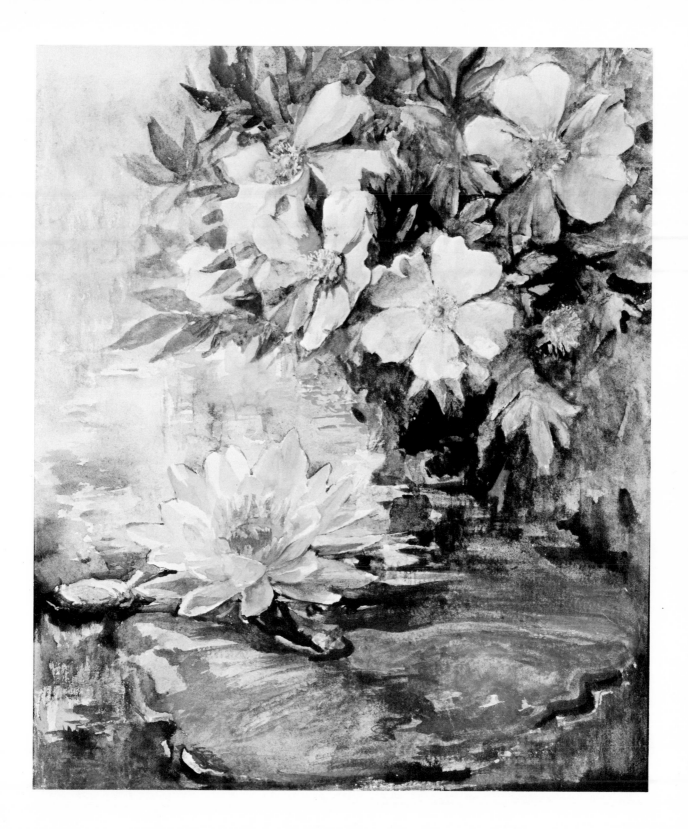

WILLIAM MERRITT CHASE

1849-1916

Chase probably taught more pupils than any other American artist and contributed far more energy than most to promoting organizations and exhibitions of both European and American art. His efforts helped to create an atmosphere in which American artists could work and develop. Duncan Phillips, collector, critic, and founder of the Phillips Memorial Art Gallery, said that Chase "deserves to be long remembered for his influence on the development of taste in the United States during the period when we were acquiring some of the artistic sagacity of Europe." Chase's appeal lies in his ability to transmit his obvious delight in painting everything—from the scales of a fish to the "creamy softness" of a woman's back. He was born in Williamsburg (now Nineveh), Indiana. His first teacher, in 1867, was Benjamin F. Hayes, a portrait painter in Indianapolis, who two years later recommended that Chase go to New York. There he studied under L. E. Wilmarth at the National Academy of Design until 1871, then he went to St. Louis where his parents had moved. With the financial help of local art patrons he entered the Royal Academy in Munich in 1872. During the late 1860s and the 1870s Munich had replaced Düsseldorf as the place for aspiring American artists to study. Under the influence of Alexander Wagner and Karl von Piloty, his teachers, Chase assimilated the current taste for the dark tonalities of Dutch and Spanish painting, while falling under the spell of the new painterly realism of Wilhelm Leibl. Before returning to America in 1878, Chase spent nine months in Venice with Duveneck and Twachtman. In New York once again, he accepted a teaching position at the newly formed Art Students League and became a member of the then-radical group, The Society of American Artists. His long teaching career saw him also at the Brooklyn Art School, The New York School of Art, and the Pennsylvania Academy of the Fine Arts. The influences on Chase's work were many: his training in Munich, his love for the Spanish painters, particularly Velázquez, his interest in the vitality of Sargent and Fortuny, the realism of Manet, the decorative arrangements of Whistler, and the light of the impressionists. In turn, Chase's own style profoundly influenced the direction of late nineteenth-century American painting toward an amalgam technique of bravura brushwork and the bright, sunlit palette of the French impressionists.

2 CHASE: Portrait of a Young Woman

Watercolor on paper; 14¾ x 10⅜ inches.
Signed (right center): Chase; about 1880.

In 1878 Chase took a studio on Tenth Street, which soon became what Charles Miller, a contemporary, called "the Sanctum Sanctorum of the aesthetic fraternity, affording midst painting, statuary, music, flowers, and flamingos (stuffed), etc., symposia most unique and felicitous, never to be forgotten by charmed participants." Writing in *The Art Journal* in 1879, John Moran touched on the variety of objects in the studio and the effect they had on visiting artists. He then spoke of Chase's paintings: "One lately seen may be alluded to. It is that of a very charming lady, with golden hair, dressed entirely in black, and standing in a natural and unconventional attitude against a background of figured silk, the prevailing tone of which is faint pink. The effect is beautiful and novel." The subject of a woman in black against a background of printed silk appears to have preoccupied the artist. We see the culmination in his portrait of Dora Wheeler (Cleveland Museum of Art) done in 1883. Portrait of a Young Woman, with the same background material that appears in the painting of Miss Wheeler, is probably a likeness of Chase's future wife. He met Alice Gerson in 1880 and often used her as a model. They were married in 1886.

EXHIBITED: National Academy of Design, New York, 1881, *14th Annual Exhibition of the American Watercolor Society,* no. 243, ill.; Art Gallery, University of California, Santa Barbara, 1964/1965, *William Merritt Chase (1849–1916),* no. 23, ill. (exhibition held in cooperation with La Jolla [California] Museum of Art; California Palace of the Legion of Honor, San Francisco; Gallery of Modern Art, New York); Metropolitan Museum, 1966/1967, *200 Years of Watercolor Painting in America,* no. 99.

EX COLL.: Moses Van Brink, Mt. Vernon, New York; [M. R. Schweitzer Gallery, New York, 1963].

22

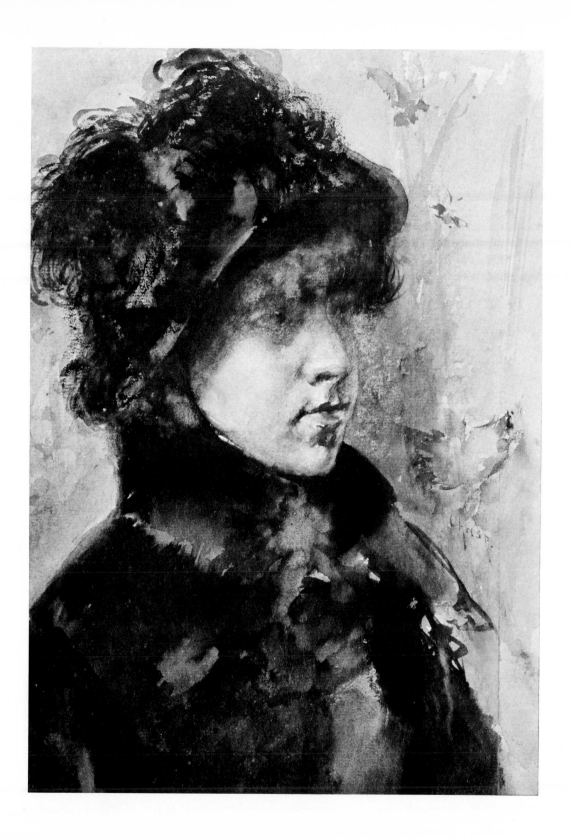

3 CHASE: Self-portrait

Pastel on paper; 17¼ x 13½ inches.
Signed (upper right): WM Chase; stamped (upper right): PP; about 1884.

In 1884 the Society of Painters in Pastel held its first exhibition in W. P. Moore's gallery. According to Chase's biographer Katherine Roof, the Society was organized in 1882 with Robert Blum as its president. The members included, among others, Beckwith, Blashfield, Blum, Chase, Kenyon Cox, La Farge, Twachtman, Irving Wiles, and J. Alden Weir. The artists marked their work with a stamp of two capital P's on a red disk with a red line below, which, looked at quickly, resembles a skull. In an 1888 newspaper review of the second exhibition, Clarence Cook said that the stamp was used on their catalogues and on the mats of their pictures. Chase seems to have preferred to put it directly on the drawing. In commenting on the first exhibition, a critic in the *Art Amateur* mentioned that "Mr. Chase's contribution included a clever portrait of himself." It is not clear whether this is a self-portrait by Chase or a portrait of Robert Blum, who much resembled Chase in the early 1880s, sporting the same short-cropped hair, vandyke, and mustache. Blum and Chase were close friends, and they traveled to Europe together in the summers between 1881 and 1885. Chase painted several portraits of Blum: Sunlight and Shadow, 1884, in the backyard of Blum's house in Zandvoort, Holland (Joslyn Memorial Art Museum); Robert Blum, about 1885–1887 (Cincinnati Art Museum); and Robert Blum, 1889 (National Academy of Design). It is tempting to think that the present pastel is the "clever portrait" of Chase in the 1884 exhibition; the artist in the picture looks aside, perhaps at his work, whereas a self-portrait painter must usually look ahead at a mirror. One clue that may confirm the identification is what looks like a carnation on the left side of the coat. Chase, somewhat a dandy and an immaculate dresser, was rarely without a white carnation.

EX COLL.: [Parke-Bernet Galleries, 1969].

24

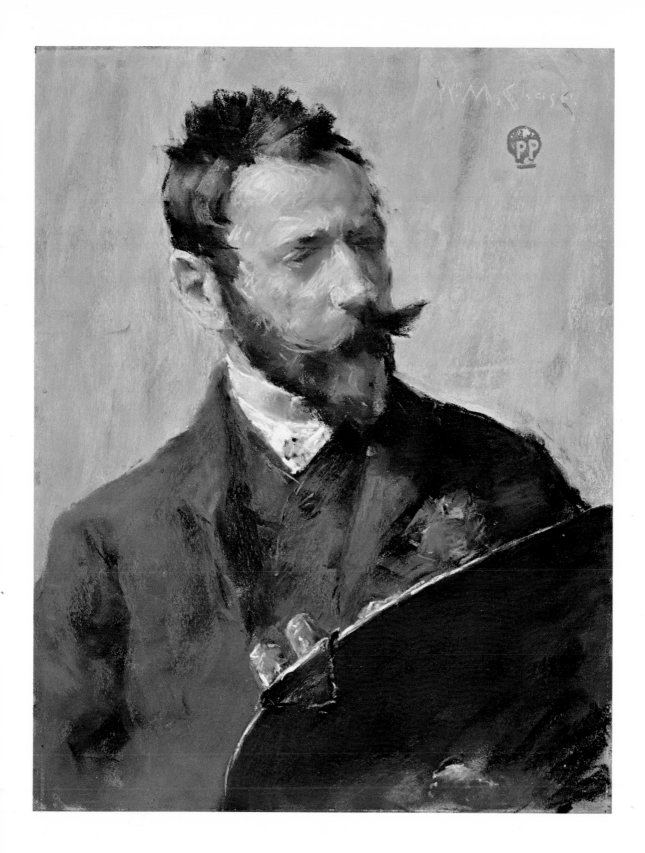

4 CHASE: Roses

Pastel on paper; 13 x 11⅜ inches.
Signed (lower left): WM Chase; stamped (lower left): PP; about 1888.

Chase said: "I find still life a thoroughly sympathetic kind of painting and I enjoin my pupils to paint still life as one of the best exercises in form and color. I am not of that school of instruction who would banish the onion from the classroom as unworthy of study." He first began to paint still lifes in his student days at the National Academy of Design. The French still-life painter Antoine Vollon was a great influence on him in subject matter and style. Both artists were fond of painting fish and kitchen scenes with big copper kettles. In contrast to his landscape and figure paintings, which tend to be lighter and more eclectic, Chase's still lifes are usually in the dark palette and bravura technique of the Munich school. This rare still life of roses shows the influence of the French impressionists. Chase and Beckwith had been responsible for including a number of French impressionist paintings in the *Bartholdi Pedestal Fund Art Loan Exhibition* at the National Academy of Design in 1884. Two years later a large show of impressionist paintings opened at the American Art Galleries. Chase's remark that "there is nothing more difficult than flowers. Avoid anything as complicated as that" may explain the scarcity of flower paintings in his work.

REFERENCE: William H. Gerdts, Russell Burke, *American Still-Life Painting*, New York, 1971, p. 201, pl. XXIV.

EXHIBITED: Wickersham Gallery, New York, 1967, *American Flowers: Loan Exhibition of Oils, Pastels, and Watercolors*, no. 5, ill.; Coe Kerr Gallery, New York, 1970, *150 Years of American Still-Life Painting*, no. 35, ill.

EX COLL.: M. Knoedler & Co., New York; Dr. and Mrs. Irving Levitt; [Kennedy Galleries, New York, 1966].

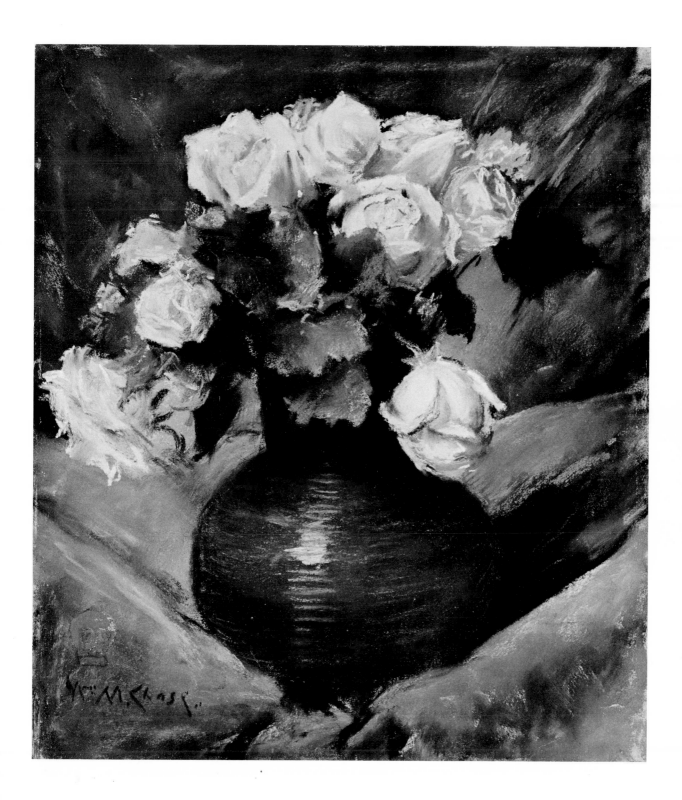

5 CHASE: Back of a Nude

Pastel on paper; 18 x 13 inches.
Signed (lower right): Wm M Chase; about 1888.

Irving Wiles, Chase's student and friend, remarked: "It was his delight in pastel that opened our eyes to the charm of that medium. Up to then no one had handled pastels in so painter-like a manner." Chase used pastels as he did oils—not as sketches but as finished pictures. In a review of the 1888 Painters in Pastel exhibition, Clarence Cook claimed that Chase had been kidded by "his brother artists" to the effect that he could do most anything, "but painting the nude figure was not in his line. The quiet answer to this has been a half dozen studies of the nude." The example in the exhibition, lent by Thomas B. Clarke, was of a full-length nude, seated, with her back to the viewer, on a green cushion. It was entitled "Pure." The reviewer remarked that this work and all the studies he had seen "throw everything else that has been done here into the shade. . . . No piece of flesh painting has been seen in these parts that could approach this performance of Mr. Chase." In the five known pastels in this series, the same model is shown from the back. The simple, evocative composition and the use of Oriental fabrics illustrate the influence of Japanese art on Chase's work.

EXHIBITED: Gallery of Modern Art, New York, 1965, *William Merritt Chase Exhibition* (not in catalogue).

EX COLL.: Florence Davis Watson, Jacksonville, Florida; Kennedy Galleries, New York; [Hirschl & Adler Galleries, New York, 1965].

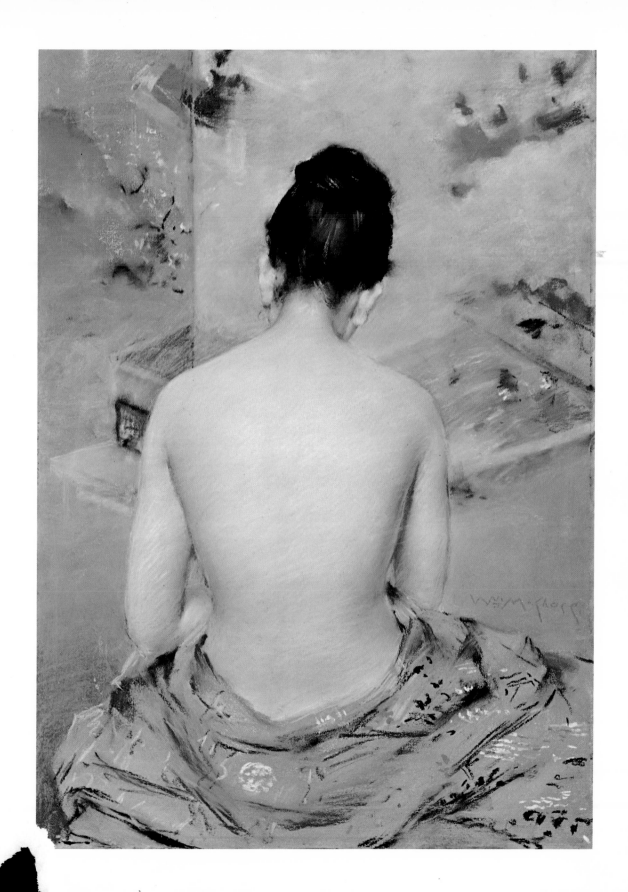

6 CHASE: The Fairy Tale

Oil on canvas; 16½ x 24½ inches.
Signed (lower right): Wm M Chase; 1892.

At the urging of summer residents, Chase started a summer school in Shinnecock Hills, Long Island, in 1891. The following year, the architectural firm of McKim, Mead, and White completed a country house and studio for Chase, and here he and his family spent most of their summers until his death in 1916. The school, however, was discontinued in 1902. Over the years Chase completed a great number of lush, sun-drenched scenes of his family playing and relaxing in the countryside. The human touch, both in scale and color, emphasizes the sweep and expansiveness of the landscape. "He used to call his oldest daughter 'his red note,'" his biographer Roof says, "because having usually a touch of red in her costume, she was constantly called upon to add that accent to his compositions." John Gilmer Speed in 1893 described the present painting:

> Of the landscapes, there is one that is particularly notable. When it comes to be exhibited I shall expect to see larger crowds before it than landscapes usually attract. The foreground is the same grass and heather before spoken of, and sitting in this a lady and a child—the lady in white with a pink hat, and the child in pink with a white hat. An open parasol lies beside them, and this, too, is pink and white. In front of the two figures, which are not merely sketched in, but finished with care and nicety as to details, is a scrub oak that seems, because its foliage mingles with the heather and grass, more like a clump of bushes than a tree. Beyond and in the distance is the Peconic Bay, with a cluster of bath-houses, and still beyond is Robbin's Island. Over all is a cloudless summer sky. [It is] one of the most finished compositions it has ever been my good fortune to see.

REFERENCES: John Gilmer Speed. "An Artist's Summer Vacation," *Harper's New Monthly Magazine*, v. LXXXVII, no. DXVII, June 1893, pp. 11–12, ill. p. 13 (as A Fairy Tale); College Art Association, *Index of Twentieth Century Artists*, v. II, no. 2, Nov. 1934, p. 25 (as Fairy Tale); William H. Truettner, "William T. Evans, Collector of American Paintings," *American Art Journal*, v. III, no. 2, Fall 1971, p. 73.

EXHIBITED: Gill's Art Galleries, Springfield, Mass., 1893, *16th Annual Exhibition of American Paintings*, no. 41, ill. (as A Sunny Day); Society of American Artists, New York, 1893, *15th Exhibition,* no. 60 (as The Fairy Tale).

EX COLL.: Macbeth Gallery, New York, to William T. Evans, 1898; American Art Galleries, New York, 1900, William T. Evans collection sale, no. 182 (as A Fairy Tale) to W. R. Beal; [Coe Kerr Gallery, New York, 1969].

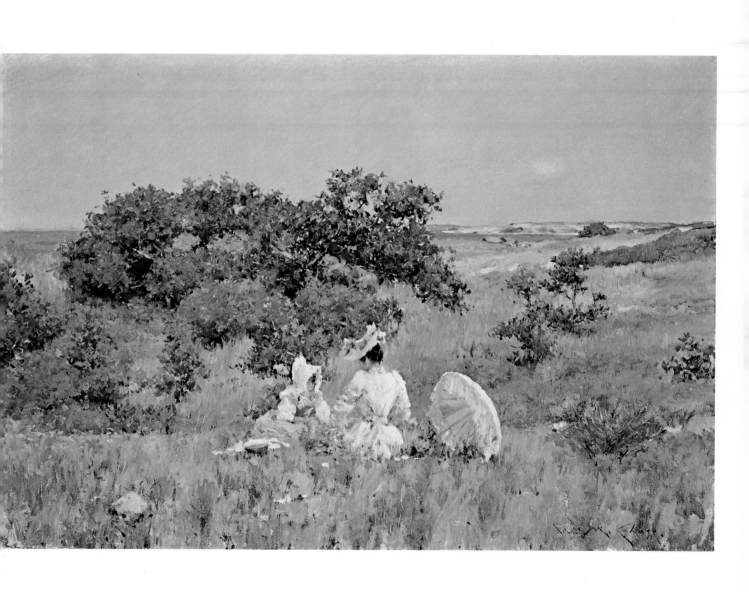

ROBERT FREDERICK BLUM

**1857-
1903**

Blum was born in Cincinnati, the home of such other artists as Duveneck, Twachtman, Potthast, and Henri. Blum's innate facile talent was more or less self-developed; his formal art training was minimal. He was apprenticed to the Gibson & Sons lithography company in 1874; in the evenings he studied drawing at the Ohio Mechanics Institute. At age eighteen he attended the McMicken School of Design. He visited the Philadelphia Centennial Exposition in 1876 and remained in the city for nine months, studying at the Pennsylvania Academy of the Fine Arts. When he arrived in New York in 1879, Alexander W. Drake, the art editor of *Scribner's Magazine,* hired him as an illustrator. In 1880 he made his first of many trips to Europe. While in Venice he spent some time with Whistler, whose etchings and pastels greatly affected his own. Soon after Blum's arrival in New York, he became friends with William Merritt Chase. The two had much in common. Both loved the intimate composition, the scene that glistened with light and color, and the opportunity to display their masterful techniques. A long-held dream came true for Blum in 1890 with a trip to Japan. This came about when he was commissioned by *Scribner's* to illustrate Sir Edwin Arnold's book *Japonica.* In 1893 he was commissioned by Alfred Corning Clark to execute two large murals (now in the Brooklyn Museum) for Mendelssohn Hall. At the time of his death he was working on murals for the New Amsterdam Theater.

7 BLUM: The Lace Makers

Oil on canvas; 16⅛ x 12¼ inches.
Signed (top center): Blum (stamp); about 1885–1887.

Blum made several visits to Venice, where a favorite artists' pastime was to sketch the local lace-making shops. Blum did an etching of lace makers dated 1885. Two years later he completed his largest version, which depicts eight girls in a large room (Cincinnati Art Museum). This was Blum's first important oil and it earned him election into the National Academy of Design as an associate member. The present work, one of a number of smaller versions, is not a fragment of the Cincinnati painting but an independent composition. In both paintings the play of indoor and outdoor light, which bathes the working women, evidences the influence of Blum's stay in Holland and the work of an artist like Vermeer. Blum's versatile technique, however, is not so much Dutch as reminiscent of the Spanish painter Fortuny, whom Blum had admired since childhood. The spontaneity and intimacy of the scene reflect his enthusiasm for life and his ability to depict with freshness something just seen.

EXHIBITED: Hirschl & Adler Galleries, New York, 1972, *Important Recent Acquisitions*, no. 7.

EX COLL.: Victor Spark; Mrs. Joan Patterson, 1960–1972; [Hirschl & Adler Galleries, 1972].

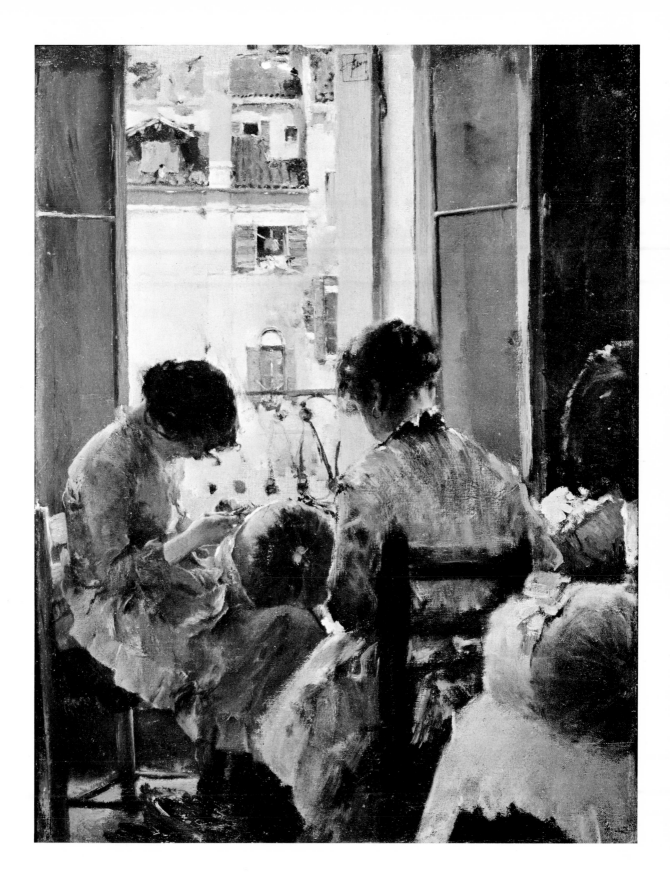

8 BLUM: Geisha

Pastel on brown paper; 11½ x 11 inches (sight); 11½ x 14¼ inches originally
(portion of blank paper folded under frame).
Unsigned; stamped by executor of estate (lower right, folded under frame):
June 23 1906; about 1890–1893.

Blum's trip to Japan in 1890 was the fulfillment of a wish he had had since 1872, when he had bought some Japanese fans at a music festival in Cincinnati. His desire was rekindled in 1876 when he saw the Japanese display at the Centennial Exposition. In addition to his illustrations for the book *Japonica,* Blum wrote and illustrated a series of articles, "An Artist in Japan," for *Scribner's,* which appeared in 1893. A geisha, similar to the present pastel, but more elaborate, was published in this series. Blum's reaction to Japan was one of curiosity. He created visual descriptions of everyday life. His work does not seem to have been influenced by Japanese art, although his life was very much affected by the experience. In a letter to Chase he wrote: "I suppose you are waiting to hear me say something about Japan. . . . It is the most puzzling experience I have ever had . . . it is simply a new world where life is on another plane — and yet one where with all its strangeness I feel strangely at home through the little insight I had of its art. But how much clearer that has become to me already by seeing the life that produced it."

EXHIBITED: Florence Lewison Gallery, New York, 1963, *19th Century Holiday,* no. 2.

EX COLL.: [Florence Lewison Gallery, 1963].

36

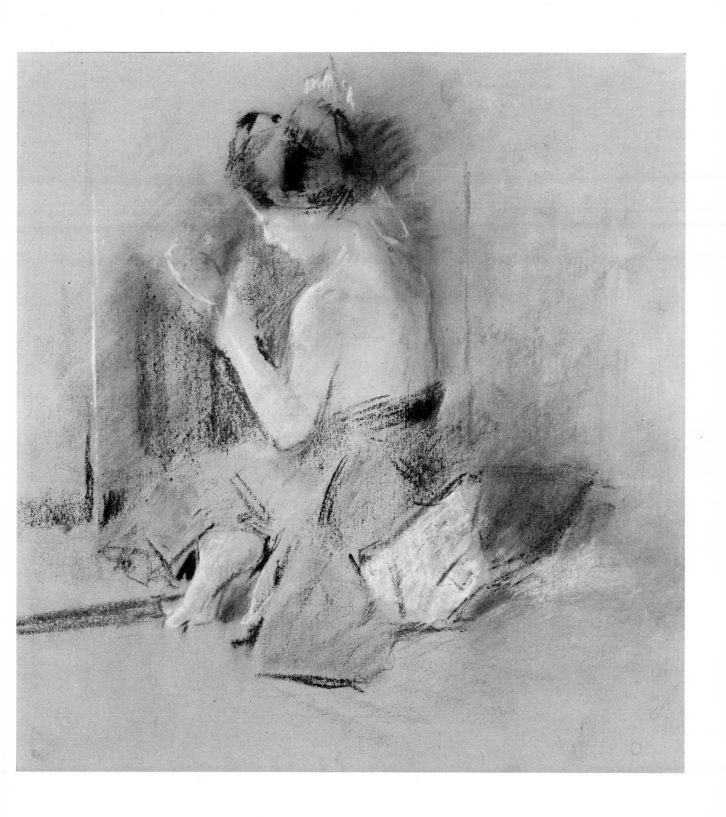

JOHN SINGER SARGENT

**1856-
1925**
Although an expatriate, Sargent retained his American citizenship and had a considerable influence on his compatriots. To them he represented European glamour and sophistication; yet his work, always elegant and au courant, was still honest and direct, qualities that appealed to the American sensibility. Sargent was born in Florence. His family led a pleasant nomadic existence, spending the winters in southern Europe and migrating to the north in the spring. Sketching people and places on these trips became a consuming interest for the young Sargent. His first formal art instruction, in 1868, was from Carl Welsch, a German-American landscapist, in Rome. Sargent then attended the Accademia di Belle Arti in Florence, and in 1874, after passing the entrance examination for the Ecole des Beaux-Arts, he entered the Parisian studio of the portraitist Carolus-Duran, who encouraged his talent for portraiture and for working directly from his subject in a painterly fashion. Carolus-Duran's dictum was "In art all that is not indispensable is harmful." The American colony in Paris was quite small and kept to itself. Even so, Sargent became friends with Carroll Beckwith and Will H. Low. He must also have known Theodore Robinson, who studied with Carolus-Duran in 1876. J. Alden Weir wrote of Sargent to his mother in 1874: "Such men wake one up, and as his principles are equal to his talents, I hope to have his friendship." During his Paris years Sargent began forming his own lasting style after such models as Velázquez and Frans Hals. At the same time he was absorbing ideas from his contemporaries—Whistler and the impressionists. His painting Two Wine Glasses (collection of the Marchioness of Cholmondeley), done in about 1875, already displayed a mature understanding of the impressionist subject matter and use of color. Sargent made his first trip to America in 1876 to visit the Centennial Exhibition in Philadelphia. By the time of his second visit in 1887 he was a celebrity: he had developed a mature style; he had traveled extensively; his tour-de-force canvas of 1882, El Jaleo (Isabella Stewart Gardner Museum), had been bought by an American dealer and was shown that same year in New York; and he had caused a scandal in 1884 at the Paris Salon with his daring Portrait of Madame X (Madame Pierre Gautreau; Metropolitan Museum). He painted over twelve portraits during his second visit, and had his first one-man exhibition at the St. Botolph Club in Boston in January 1888. In 1890 he received a commission for the mural decoration of a hall in the Boston Public Library. Other commissions for murals followed, and he made numerous trips to this country to supervise the work.

9 SARGENT: Under the Willows

Watercolor and pencil on paper; 14 x 9⅜ inches.
Unsigned; inscribed and dated (back of paper): "Under the Willows 1888/
Flora Priestley and Viol. . . / Given to Violet Sargent by her. . . ?"

Sargent moved to England in 1886, and London became his home for the rest of his life. Upon his return from America in May 1888, he took a summer house at Calcot on the Thames. Various friends joined the family that summer, including Dennis Bunker. Then and the next summer at Fladbury, Sargent created his most French-inspired impressionist paintings. Claude Monet was the direct influence. When their friendship began is not clear, although it seems certain that Sargent was in Giverny the summer of 1887 (the same year that Robinson and Metcalf were there). At that time he painted a profile portrait of Monet (National Academy of Design, New York). That same year he acquired a painting by Monet, Rock at Tréport (collection of John G. McConnell, Montreal), which he enthusiastically praised in a letter to the artist. Unlike Monet, however, he could never paint in totally aesthetic terms; he had no interest in formulas, only in transcribing what he saw before him. Sargent had used watercolor since he was a child, but it was not until after 1900 that he used it with any regularity. This rare early watercolor sketch illustrates the softness and the dreamy quality of his work in the late eighties. Violet Sargent, the painter's sister, and Flora Priestley, a family friend, lounge on the bank of the Thames. Miss Priestley met Sargent in the early 1880s when she was studying art in Paris. They became lifelong friends; there were even rumors of a romance. He did many similar oil sketches of Violet alone, or with friends, in the surrounding countryside during the summers of 1888 and 1889. This period of freedom, exploration, and vitality ended about 1890, and it was not until he had achieved fame and financial success that Sargent could again return to painting for his own enjoyment.

REFERENCES: Richard Ormond, *John Singer Sargent, Paintings, Drawings, Watercolors*, New York, 1970, p. 69 (as Two Figures in a Landscape); Richard Ormond, Letter to D. H. P., 7 Nov. 1972.

EXHIBITED: Corcoran Gallery of Art, Washington, D.C., 1964, *The Private World of John Singer Sargent*, no. 96.

EX COLL.: Mrs. Hugo Pitman (Sargent's niece); [James Coats, New York, 1962].

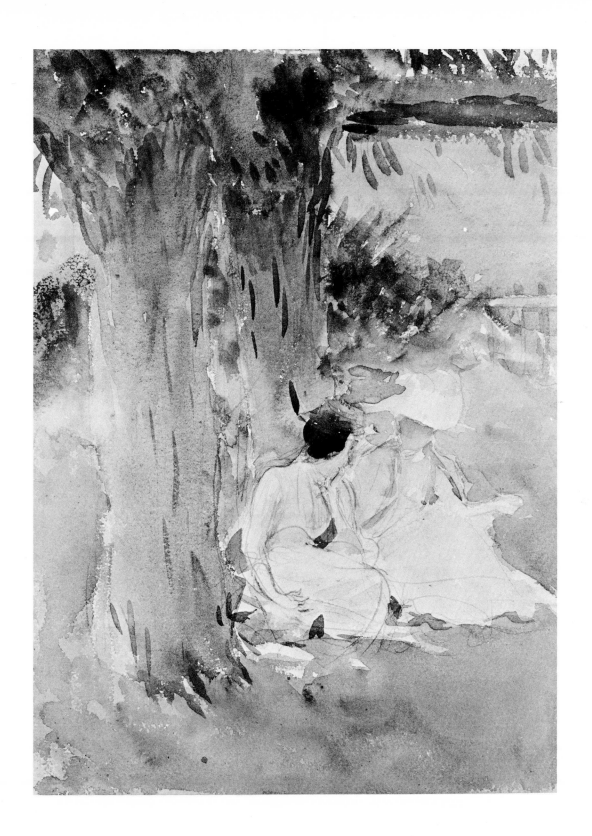

10 SARGENT: Gondoliers' Siesta

Watercolor on paper; 14 x 20 inches.
Signed, dated, and inscribed (lower right); "To Mrs. Gorham Sargent from
her affectionate nephew John S. Sargent 1905."

Venice had fascinated Sargent since the summer of 1880, when he took a studio at
the Palazzo Rezzonico. He returned again and again throughout his life, for the
city provided him with his favorite visual material: water, architecture, boats, and
wonderful light and atmospheric effects. His watercolors, when he began to paint
them regularly after 1900, became a form of relaxation and an escape from the
rigors of his official portraiture. Sargent was more open and casual in his water-
colors, perhaps because most of them were never intended for exhibition. Many of
them were given as gifts to family and friends, as this one was. Dating his water-
colors of Italy, Spain, and the Alps is difficult, as he did the same subjects over and
over again, and returned to the same places year after year. Unlike most of the
watercolors, Gondoliers' Siesta is dated, and we can recognize Sargent's style of
1905. His technique was swift and assured; he usually spent only one session on a
work. He often painted on dry paper, sometimes quickly sketching in pencil the
general placement and perspective of the design. Then with great gusto he applied
washes of color with large brushes or sponges. He sometimes used gouache to
strengthen forms, and often relied on the white of the paper for highlights. Sargent
loved to paint from a gondola, as in this scene in front of the Palazzo Contarini
delle Figure on the Grand Canal. As in so many of these Venetian scenes, he con-
centrates on the foreground objects or figures. The impact is direct and immediate.
He relates exactly what he sees, almost never changing buildings, proportions, or
a scene for the sake of design. As David McKibbin, who is preparing a catalogue
raisonné of Sargent's work, suggests, one could illustrate a book on Venice using
just Sargent's watercolors.

REFERENCES: *Collector and Art Critic,* v. 14, June 1906, p. 241, ill. (as Venice); Leila
Mechlin, "The Philadelphia Water Color Exhibition," *International Studio,* v. 28, June 1906,
p. CXI, ill. (as Venice); *American Magazine of Art,* v. 10, Feb. 1919, ill. p. 143 (as Venetian
Street Scene); William Howe Downes, *John S. Sargent, His Life and Work,* Boston, 1925,
p. 282 (as Venetian Street Scene); *American Magazine of Art,* v. 16, June 1925, p. 287, ill.
(as Venice); *Ferargil,* v. 2, no. 2, Oct. 1926, n.p., ill. (as Gondoliers); David McKibbin,
Letter to D. H. P., 10 Aug. 1972.

EXHIBITED: Pennsylvania Academy of the Fine Arts, Philadelphia, 1906, *3rd Annual Phila-
delphia Water Color Exhibition,* no. 389, ill. (as Venice); Gallery of Modern Art, New York,
1965, *Major 19th and 20th Century Drawings* (no catalogue); Metropolitan Museum, 1966/
1967, *200 Years of Watercolor Painting in America,* no. 105.

EX COLL.: Mrs. Gorham Sargent; Ferargil Gallery, New York; Mrs. Irving Telling, New
Haven, Conn., to [Vose Galleries, Boston, 1963].

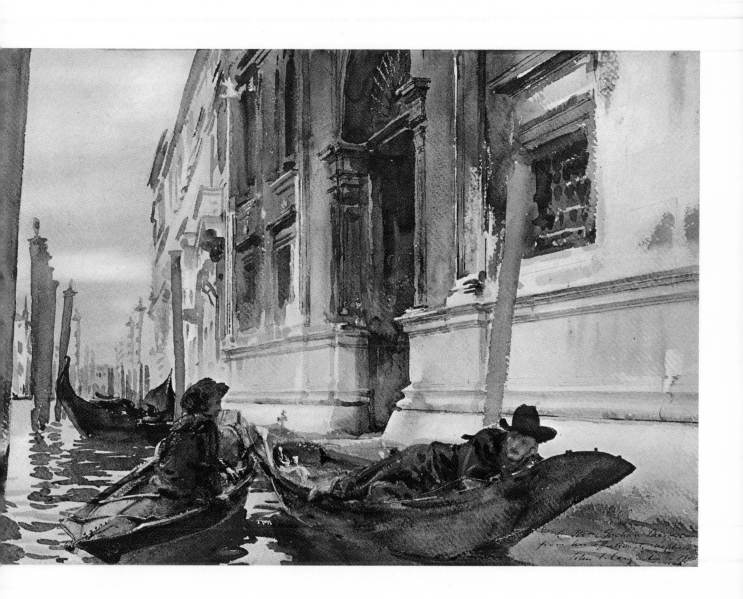

11 SARGENT: Lady Seated Beside an Alpine Pool

Oil on canvas; 31½ x 45⅜ inches.
Unsigned; about 1911.

By 1900 Sargent was growing dissatisfied with the restrictions of portraiture and beginning to take a renewed interest in landscape painting. He could now afford to take long summer vacations, usually spending the hottest months in the Alps at Purtud in the Val d'Aosta or at the Simplon Pass. As in his late watercolors, his approach in oil is direct; these pictures are statements about light, color, and the joy of applying paint, not travelogues of people and places seen or remembered. He delighted in his freedom to depict the figure as just another pictorial element in the landscape; in many paintings of this period the human form is almost assimilated into its surroundings. The style and mood are very different from his impressionist paintings of the 1880s, but he is still striving for the same effect: the transcription of what was before him, defined by light and color. There was always a large group of his family and friends who joined him in the Alps from 1907 onward, and he endlessly used his guests as the subjects of his paintings. It is thought that Polly Barnard sat for Lady Seated Beside an Alpine Pool in 1911. As children, Polly and her sister, Dorothy, had posed for Carnation, Lilly, Lilly, Rose (Tate Gallery, London), done between 1885 and 1886. Emily Sargent wrote to Henry Tonks in 1911 from the Simplon-Kulm Hotel, perhaps describing the day this painting was started: "The Barnards are very well—There have been great cricket matches, & some mountaineering on a small scale. . . . I am writing out of doors—John seized what seemed to be this cloudy morning, to go on with an oil sketch of Polly Barnard, in silk skirt & cashmere shawl. Just as everything was ready, now the sun has come out, & he is beginning a sunny one!"

REFERENCES: "Sargent as Landscape-Painter: His Less-Known Side in a Coming Sale," *Illustrated London News*, v. 167, 11 July 1925, p. 65, ill.; Hon. Evan Charteris, *John Sargent*, New York, 1927, p. 290 (as Alpine Pool), p. 295 (as Landscape with Woman Seated in Foreground); Charles Merrill Mount, *John Singer Sargent: A Biography*, New York, 1955, no. K1012, p. 450.

EXHIBITED: Brooks Memorial Art Gallery, Memphis, Tenn., 1957, *Paintings by John Singer Sargent from Boston Museum Collection* (no catalogue no.).

EX COLL.: Christie, Manson & Woods, London, 1925, Pictures and Water Colour Drawings by J. S. Sargent, R. A. and Works by Other Artists, sale, no. 96, to Scott & Fowles, New York; Parke-Bernet Galleries, New York, 1946, Scott & Fowles sale, no. 39 (withdrawn); Parke-Bernet Galleries, 1946, Mrs. Edna Lemle sale and others, no. 56 (withdrawn?); Leon Dalva until 1960; Plaza Art Galleries, New York, 1960, to Mr. and Mrs. Lewis Sacker to [Robert Elkon Gallery, New York, 1968].

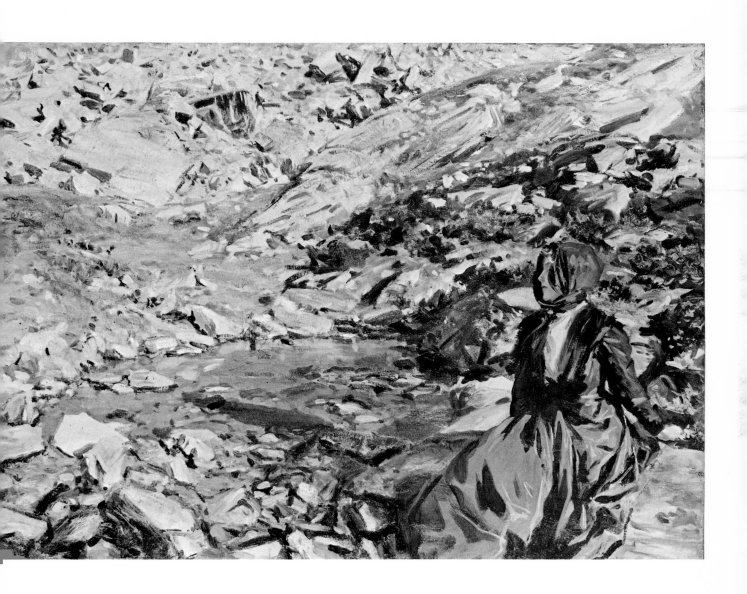

DENNIS MILLER BUNKER

1861-1890

An artist of great promise, Bunker died at twenty-nine, too soon to have developed his talents fully. Nevertheless, he left behind an impressive body of work. He was born in Garden City, New York, and at seventeen began study at the Art Students League under William Merritt Chase and at the National Academy of Design. Before leaving for France in 1882, he learned landscape painting from Charles Melville Dewey and may have come under the influence of Eastman Johnson on his summer trips to Nantucket. In Paris Bunker spent a few months at the Academy Julian under Hébert before entering the atelier of Jean Léon Gérôme at the Ecole des Beaux-Arts. Under Gérôme's tutelage he developed into a superb draughtsman, as can be seen in his later portraits, especially the one of Anne Page (collection of Mr. and Mrs. Leonard Hersey). Upon his return to America in late 1884 or early 1885, he taught at the newly opened Cowles Art School in Boston. Although he lived there for only four years, he is considered a Boston painter. He was a contemporary of Tarbell, Benson, and Joseph De Camp, yet he attached himself to an older generation, to Abbott Thayer in particular. Bunker enjoyed the friendship and patronage of Isabella Stewart Gardner, founder of the museum in Boston.

12　BUNKER: Low Tide

Oil on canvas; 14½ x 20½ inches.
Signed (lower right): D.B.; about 1884–1887.

Very little is known about Bunker's work before 1888, though he exhibited as early as 1880 at the National Academy of Design. For the next two years the titles of almost all the paintings he showed revealed his interest in boats and water. We have little evidence from his Paris years (1882 to late 1884 or early 1885) to show that he was aware of impressionism, and certainly his landscapes of the period, with their overall tones of green and brown, recall more the Barbizon painters. Yet the daring composition of Low Tide, with its dramatic perspective and abrupt cutting off of the boat in the foreground, clearly reflects the aesthetic approach of the impressionists. One thinks of Manet's Boating (Metropolitan Museum) of 1874, which Bunker could have seen when it was exhibited at the Ecole des Beaux-Arts in 1884. Reminiscent of Manet are the placement of the boat in Low Tide, the treatment of the rigging on the right, and the overall sketchy quality, but here the similarities end. Ives Gammell, noting that hardly any landscapes survive from the many Bunker painted during 1886 or 1887, says that almost all of these, like Low Tide, are of gray days. Since his style completely changed after 1888, Bunker probably did this painting, with its academic solidity and Barbizon tonality, in the mid-eighties.

REFERENCES: R. H. Ives Gammell, *Dennis Miller Bunker,* New York, 1953; John Canaday, "Art: The American Impressionists, Big and Little," *New York Times,* 16 Nov. 1968, ill.

EXHIBITED: Museum of Fine Arts, Boston, 1943, *Dennis Miller Bunker, Exhibition of Paintings and Drawings,* no. 22; Hirschl & Adler Galleries, New York, 1968, *The American Impressionists,* no. 8.

EX COLL.: Mrs. William G. Thayer; [Hirschl & Adler Galleries, 1969].

48

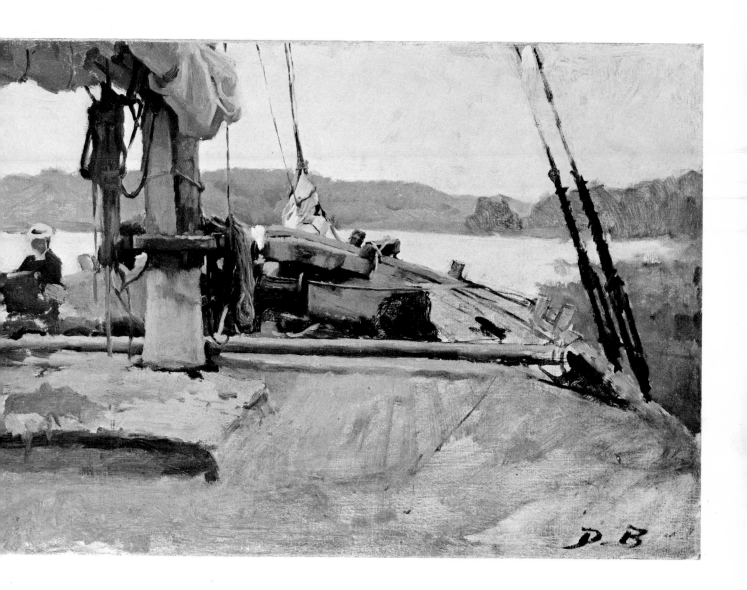

13 BUNKER: Roadside Cottage

Oil on canvas; 25$\frac{1}{16}$ x 30 inches.
Signed and dated (lower right): D. M. Bunker / 1889.

Bunker was obviously exposed to the art of the impressionists while he was in Paris, but it was not until the summer of 1888 that their concern with color, light, and atmospheric effects began to influence his painting. The new direction of his work was not inspired by a Frenchman but rather by the American John Singer Sargent, whom Bunker first met in Boston when Sargent was painting portraits there during the winter of 1887/1888. The following summer Bunker joined the Sargent family in Calcot, England, where the two artists painted the countryside. Sargent's landscapes of this period mark the climax of his impressionist phase and his admiration for Monet. His enthusiasm must surely have been contagious, for back in America, at Medfield, Massachusetts, in 1889, Bunker painted some of his finest and most impressionistic landscapes. This scene could be his Medfield boardinghouse, which he described as "a funny charming little place, about as big as a pocket-handkerchief with a tiny river, tiny willows and a tiny brook." The painting vibrates with color and light and, in its fluid brushstrokes and diffused light, closely resembles Sargent's work; like the older artist, Bunker could not wholly immerse his forms in light and color. What Richard Ormond says about Sargent applies as well to Bunker: "His art was founded ultimately on analysis and definition, the literal transcription of what lay before him. Impressionism was for him only a refining of one's means towards representing things, not an all-embracing credo."

REFERENCES: R. H. Ives Gammell, *Dennis Miller Bunker*, New York, 1953; Richard Ormond, *John Singer Sargent, Paintings, Drawings, Watercolors*, New York, 1970.

EX COLL.: [An anonymous collector].

50

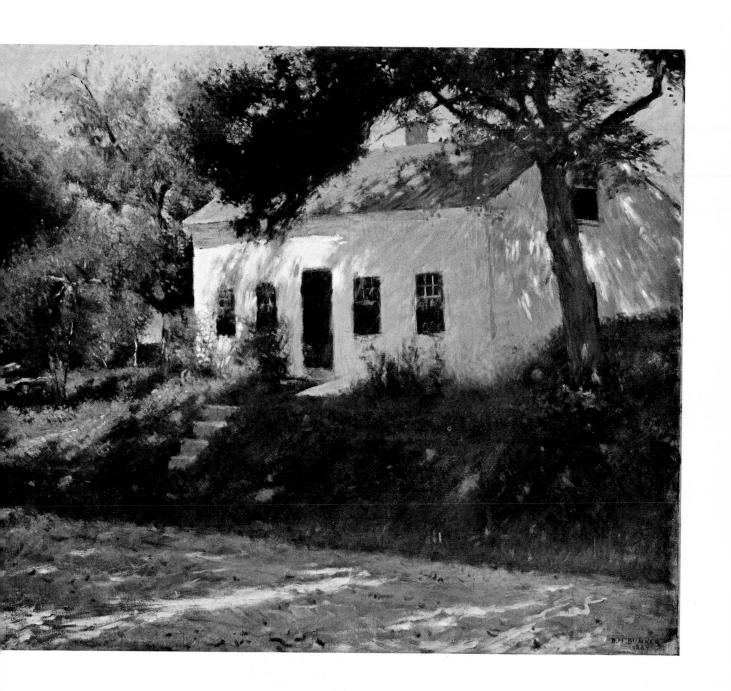

THEODORE ROBINSON

1852-1896

Theodore Robinson was one of the first American artists to be directly influenced by the French impressionists, by Claude Monet in particular. John I. H. Baur, the leading authority on Robinson, wrote: "The ultimate and lasting virtue of Robinson's painting, quite aside from its pioneering role in American impressionsm, was a gentle, almost feminine lyricism, rooted in naturalism and achieved through color and an eye that was sensitive to the intimate poetry of nature and of daily existence." Robinson was born in Irasburg, Vermont, but spent his childhood in Evansville, Wisconsin. Decided upon an art career, he studied briefly in Chicago in 1869. Five years later he enrolled at the National Academy of Design in New York and then, in 1876, continued his training with Carolus-Duran and Gérôme in Paris. By 1879 Robinson was back in New York teaching and doing decorative work for La Farge; in 1883 he worked for Prentice Treadwell on mural decorations for the Metropolitan Opera House. He returned to Europe in the spring of 1884 and, except for brief interludes at home, remained there for the next eight years. His work had a direct influence on that of Twachtman and Weir, and would probably have had a more profound effect if it had not been for his frail health and early death.

14 ROBINSON: Self-portrait

Oil on canvas; 13¼ x 10¼ inches.
Signed and inscribed (lower right): "Robinson peint par lui même";
about 1884–1887.

Robinson's early painting comes out of the Homer-Eakins realist tradition, although his palette is somewhat lighter. He spent most of his first four years abroad in Barbizon and Paris, and his work of this period is dark, thinly painted, and small in scale. He is no longer interested in color and light and atmospheric effects. John I. H. Baur notes that these paintings "have directness and a subdued luminosity, while their subordination of detail gives them a degree of unity which Robinson had not achieved before." He could have been describing this self-portrait. A contemporary description of the artist by Birge Harrison gives us insight into Robinson's personality and perhaps his reasons for painting a profile view of himself rather than the usual full face:

> Robinson was far from handsome in the classic sense. An enormous head, with goggle-eyes and a whopper jaw, was balanced on a frail body by means of a neck of extreme tenuity; and stooping shoulders, with a long, slouching gait, did not add anything of grace or beauty to his general appearance. But when one of the French comrades threw an arm around his shoulders, and casting a sidewise and puzzled glance upon him remarked, 'Tu es vilain, Robinson; mais je t'aime,' we all understood, for out of those goggle-eyes shone the courage of a Bayard, and in their depths brooded the soul of a poet and dreamer, while his whole person radiated a delightful and ineffable sense of humor.

REFERENCES: *Art Digest,* v. 17, no. 14, 15 April 1943, ill. p. 5; John I. H. Baur, *Theodore Robinson, 1852–1896,* New York, 1946; Charles E. Slatkin Galleries, *Claude Monet and the Giverny Artists,* New York, 1960, n.p., ill.; Florence Lewison, "Theodore Robinson, America's First Impressionist," *American Artist,* Feb. 1963, ill. p. 40.

EXHIBITED: Babcock Galleries, New York, 1928, *Exhibition by American Artists,* no. 16; Babcock Galleries, 1928, *Selected Small Paintings by Prominent American Artists,* no. 3; Macbeth Gallery, New York, 1943, *Theodore Robinson 1852–96,* no. 21, ill. on catalogue cover; Brooklyn Museum, 1946, *Theodore Robinson, 1852–1896,* no. 206.

EX COLL.: A. Conger Goodyear to Babcock Galleries (1928–1930) to Goodyear; M. Knoedler & Co., New York; William T. Cresmer to Cresmer estate; Hanzel Galleries, Chicago; [Babcock Galleries, 1961].

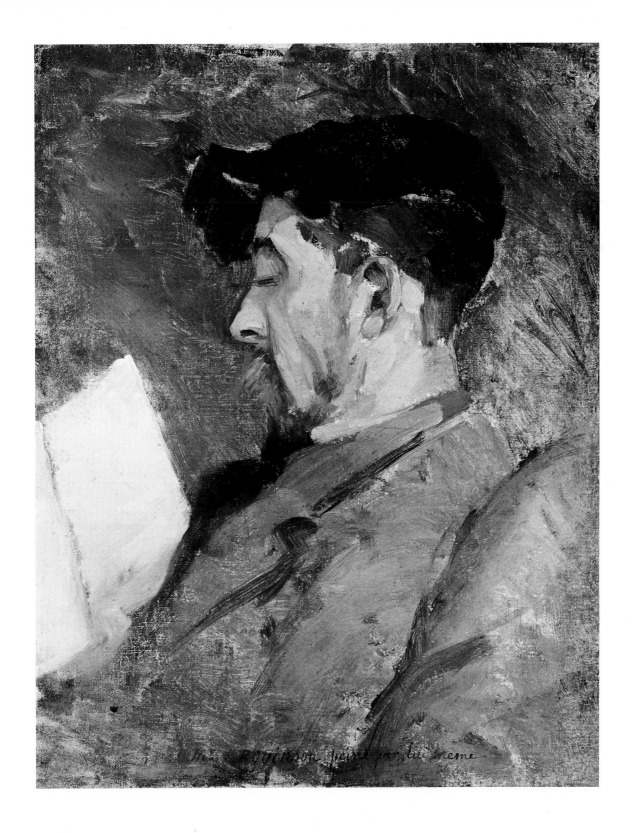

15 ROBINSON: Young Woman Reading

Watercolor on paper; 19⅜ x 13¾ inches.
Signed, dated, and inscribed (lower right): T H Robinson/Paris 1887.
(Also called Young Lady Reading; Lady in Red Reading).

About 1885 a new trend developed in Robinson's work. The stylization that marked his decorative work for La Farge and Treadwell reasserted itself in a number of figure studies he did sporadically over the next four years. These self-conscious paintings, with their flat patterns and flowing lines, represent a stylistic development that is outside the main body of his work. Another explanation for the rather static quality sometimes found in his figure compositions was his use of photographs for both his oil and watercolor paintings. He seems to have first used the camera in the early 1880s. Later he was not convinced that relying on photographs was wise. "In the past," he wrote, "too many things began well enough, but too much photo, too little model, time, etc." Young Woman Reading seems to suggest Robinson's early respect for Homer in its solidity of form and recalls his own student work in its meticulous draughtsmanship.

REFERENCES: John I. H. Baur, *Theodore Robinson, 1852–1896*, New York, 1946; Kennedy Galleries, *Theodore Robinson, American Impressionist (1852–1896)*, New York, 1966, p. 11.

EXHIBITED: Brooklyn Museum, 1946, *Theodore Robinson, 1852–1896*, no. 335; Florence Lewison Gallery, New York, 1962, *Theodore Robinson*, no. 18.

EX COLL.: Mrs. Charles Kelsey; M. Knoedler & Co., New York; Kende Galleries, New York, 1942, John F. Braun sale, no. 15; Jesse Sobol; [Florence Lewison Gallery, 1962].

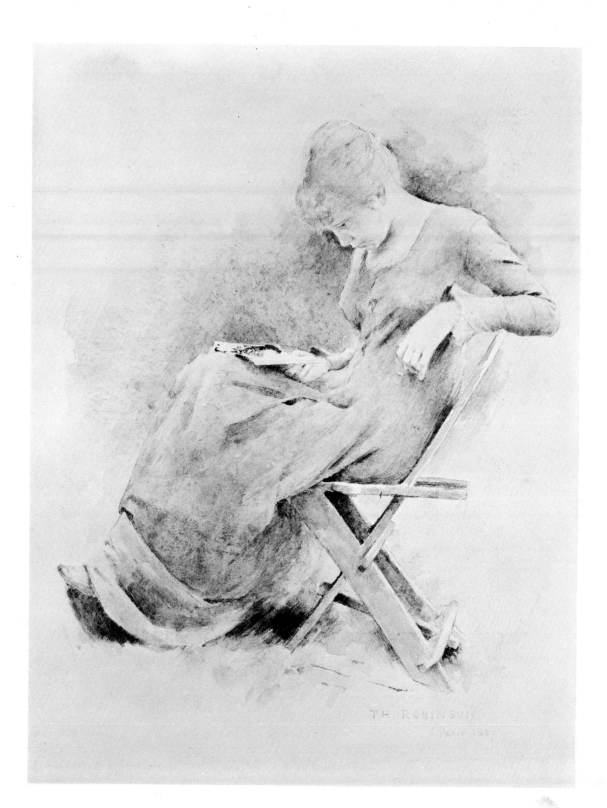

TH ROBINSON
Paris 1887

16 ROBINSON: From the Hill, Giverny

Oil on canvas; 16 x 25½ inches.
Unsigned; about 1889.

Robinson discovered Giverny, the home of Claude Monet, in 1887. Other American artists were there too, including Louis Ritter, W. L. Metcalf, Theodore Wendel, and John Breck. "A few pictures just received from these young men," reported the *Art Amateur* of October 1887, "show that they have all got the blue-green color of Monet's impressionism and 'got it bad.'" Such negative comment aside, Robinson's work came into its own under the stimulus of impressionism and his enduring friendship with Monet. In December 1888, Robinson returned to New York. His impressionist paintings, the first sizable group to be exhibited by an American, were shown that spring at the Society of American Artists. By May he was back in Giverny experimenting further. Robinson's style illustrates the difficulty most Americans had in reconciling the impressionists' dissolution of form into scintillating broken color with their own inherent tradition of representational realism. From the Hill, Giverny was probably painted during the summer of 1889. Robinson did a number of similar versions, one of which is Bird's Eye View—Giverny, dated 1889 (Metropolitan Museum). In this series the view of Giverny is from a sloping hill in the foreground of the picture plane, with a patchwork of gaily colored village rooftops nestled in the middle ground and the flat Norman plain and the sky beyond. Both Monet's influence, in the light pastel palette, fragmented color, and hazy atmospheric effect, and Robinson's own entrenched realism can be seen in this landscape.

REFERENCES: Frederic Fairchild Sherman, "Theodore Robinson," (unpublished manuscript in Frick Art Reference Library), n.d., no. 32; John I. H. Baur, *Theodore Robinson, 1852–1896*, New York, 1946; Kennedy Galleries, *Theodore Robinson, American Impressionist (1852–1896)*, New York, 1966, p. 12.

EXHIBITED: Macbeth Gallery, New York, 1923, *Paintings by Emil Carlsen, Theodore Robinson, J. Alden Weir*, no. 6; Babcock Galleries, New York, 1927, *Watercolors and Paintings by American Artists*, no. 19; Babcock Galleries, 1929, *Paintings, Watercolors, Etchings by American Artists*, no. 34; Brooklyn Museum, 1932, *Catalogue of an Exhibition of Paintings by American Impressionists and Other Artists of the Period 1880–1900*, no. 75; Babcock Galleries, 1936, *Paintings by American Masters*, no. 16; Babcock Galleries, 1937, *Well Known American Artists*, no. 5; Macbeth Gallery, 1943, *Theodore Robinson, 1852–96*, no. 7 (?); Babcock Galleries, 1946, *Paintings and Watercolors by American Artists*, no. 8; Brooklyn Museum, 1946, *Theodore Robinson, 1852–1896*, no. 72; M. Knoedler & Co., New York, 1965, *Lawyers Collect*, no. 54; Metropolitan Museum, 1966, *Summer Loan Exhibition: Paintings, Drawings, and Sculpture from Private Collections*, no. 159; Metropolitan Museum, 1967, *Summer Loan Exhibition: Paintings from Private Collections*, no. 92; Newark Museum, N.J., 1969, *Light and Atmosphere: American Impressionist Painters* (no catalogue).

EX COLL.: American Art Association, New York, 1898, Theodore Robinson sale, no. 3, to J. Busbee; Ferargil Gallery, New York to C. L. Baldwin; American Art Association, 1926, Baldwin sale, no. 20, (ill.) to Babcock Galleries; Joseph Katz to Katz estate; [Zabriskie Gallery, New York, 1964].

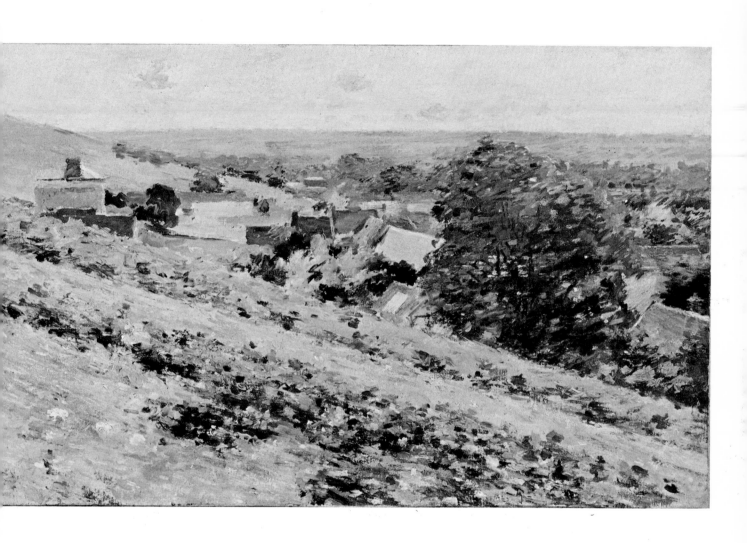

17 ROBINSON: A Normandy Mill

Watercolor on gray academy board; 9⅞ x 15 inches (sight).
Signed and dated (lower left): Th. Robinson/1892.

Early in 1890 Robinson returned to New York. That spring he received from the
Society of American Artists his first public recognition, the Webb Prize. His Winter
Landscape was the first impressionist painting to be so honored. In March 1892 he
had his first large exhibition, with Theodore Wendel, at the Williams and Everett
Gallery in Boston. Few of the works were bought, and, as it was competing with a
Monet show at the St. Botolph Club, the exhibition received little attention. In
May 1892 Robinson returned to Giverny for what was to be his last summer. At
this time he painted at least four versions of this road leading to an old mill. Two
were painted in daylight (The Old Mill, Metropolitan Museum; and Road by the
Mill, dated 1892, Cincinnati Art Museum) and two at night (Moonlight, Giverny,
no. 144 in the Baur catalogue; and Moonlight, Giverny — Study, Salmagundi Club).
The subtlety and softness of moonlit subjects had interested him since 1889 when
he painted Harvest Moon, Giverny. His style in 1892 had become diffuse; outlines
were hazy and color was applied in wide, loose brushstrokes, almost reminiscent of
Twachtman's work.

EX COLL.: An English collection; [Bernard Black Gallery, New York, 1968].

60

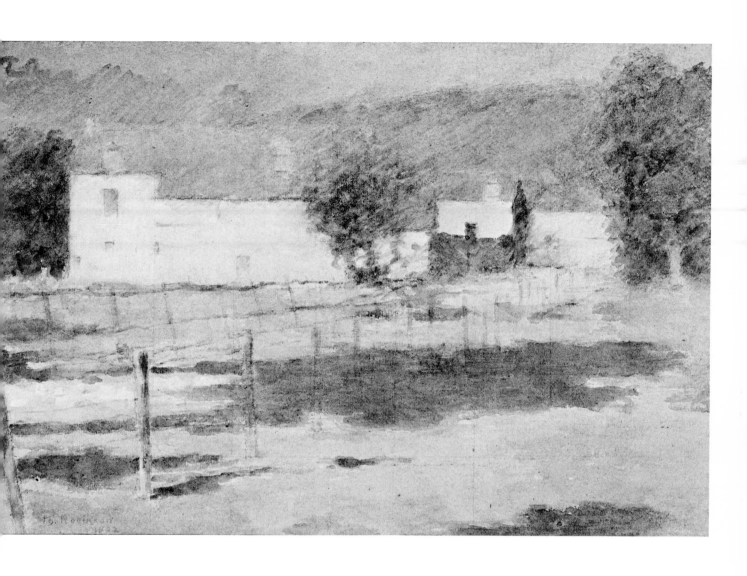

18 ROBINSON: Low Tide, Riverside Yacht Club

Oil on canvas; 18 x 24 inches.
Unsigned; 1894.

Robinson returned to America for the last time in December 1892. He was disappointed with his recent work and was intensely aware of his continuing inability to represent structural, three-dimensional forms using impressionist techniques. He began to make a conscious effort to find a more American mode of expression by modifying his color and sometimes his forms. Many factors reinforced his concern with style, not the least of which was the influence of Japanese prints. In the spring of 1894 he went to Cos Cob, Connecticut, to be close to his good friends Twachtman and Weir. There he began to "work with interest—especially from the R.R. bridge, late afternoon, [near] the clubhouse and little yachts at anchor, low tide." (Robinson's diary, Cos Cob, 6/19/94). The Cos Cob pictures (including the present one) are recognized as among his best. They are full of color, crisp handling, and spatial subtlety.

REFERENCES: Macbeth Gallery, *Art Notes,* New York, 1927, no. 85, n.p., ill.; Parke-Bernet Galleries, *American Paintings and Drawings,* New York, 1964, no. 53, ill. p. 26; Kennedy Galleries, *Theodore Robinson, American Impressionist (1852–1896),* New York, 1966, p. 15.

EXHIBITED: Macbeth Gallery, 1895, *Theodore Robinson,* no. 3; *Cotton States and International Exposition,* Atlanta, 1895, no. 514; Brooklyn Museum, 1934, *Exhibition of Paintings by American Impressionists and Other Artists of the Period 1880–1900,* no. 79; Brooklyn Museum, 1946, *Theodore Robinson, 1852–1896,* no. 138, ill. pl. XXXIV (catalogue by John I. H. Baur); Metropolitan Museum, 1966, *Summer Loan Exhibition: Paintings, Drawings, and Sculpture from Private Collections,* no. 161.

EX COLL.: American Art Association, New York, 1898, Theodore Robinson sale, no. 86, to C. Armstrong; Ferargil Gallery, New York, 1926, to Macbeth Gallery; D. A. Schmitz; [Parke-Bernet Galleries, 1964].

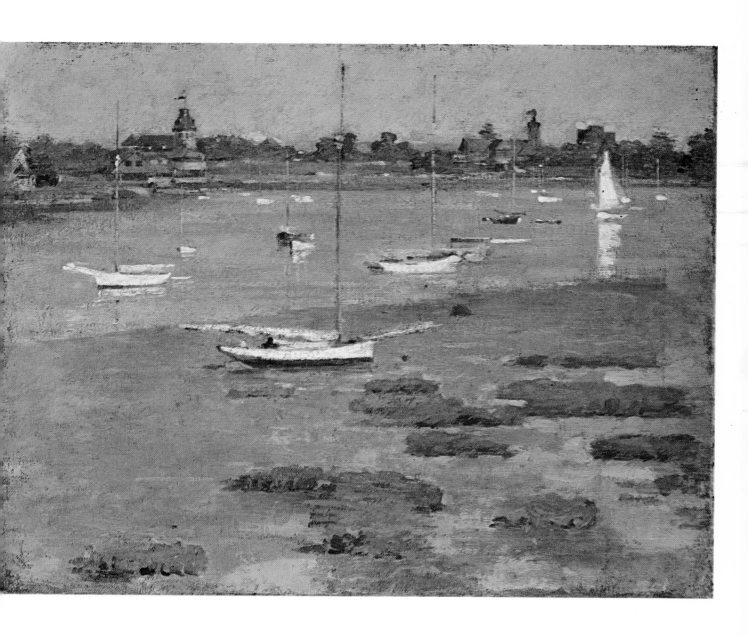

JOHN HENRY TWACHTMAN

1853-1902

Unlike most of his contemporaries, who were interested in recording the transitory effects of light and atmosphere, Twachtman wanted to capture the mood of a landscape. He was born in Cincinnati and in 1868 enrolled in the evening drawing class at the Ohio Mechanics Institute; in 1871 he transferred to the McMicken School of Design. The painter Frank Duveneck, a family friend, took Twachtman under his wing in 1874 and encouraged him to enter the Munich Royal Academy, where he studied under Ludwig Loefftz. Along with Duveneck and William Merritt Chase, Twachtman went to Venice for a year in 1877. Already it was evident that landscape painting was to become his sole interest. From the beginning he had a natural inclination to reduce pictorial elements to their essentials. This abstraction was further influenced by the work of Whistler, which Twachtman saw in 1880 when he, with Duveneck and his students, visited Venice again. After his marriage to Martha Scudder in 1881, he went to England; then Holland, where he met Anton Mauve and painted with J. Alden Weir and his brother John; then Belgium, where he met Jules Bastien-Lepage, whose work he criticized as too representational. Finally he returned briefly to Germany. Studying in Paris at the Academy Julian between 1883 and 1885, Twachtman radically changed his style from the thick impasto, facile brushwork, and dark palette of his Munich period to low-keyed, almost monochromatic colors applied in thin washes. The emphasis is on broad, flat areas of color that create a strongly patterned effect reminiscent of Japanese prints. In Paris Twachtman met Hassam, Benson, Tarbell, Robert Reid, Metcalf, and Robinson. Back in America, his career advanced slowly, although he did win the Society for American Artists' Webb Prize for The Windmills in 1888. The following year he began his thirteen years of teaching at the Art Students League. Twachtman finally achieved some prominence in 1893 when the American Art Galleries mounted an unusual exhibition comparing the work of the Frenchmen Monet and Besnard with the Americans Twachtman and Weir. It is curious that these Americans were chosen instead of, say, Hassam and Robinson, who worked more in the style of their French counterparts. One critic found that the Americans had "none of the splendid barbaric color that distinguishes the work of the French men." Twachtman, who had helped found the Ten American Painters group and was a source of strength to Weir and Robinson in their early experimental days, died despondent over his own lack of success.

19 TWACHTMAN: Trees in a Nursery

Pastel on paper; 18 x 22 inches.
Inscribed (back of paper): Twachtman #3; about 1885–1890.

The renaissance of pastel at the end of the nineteenth century in America can in large measure be attributed to the influence of James Abbott McNeill Whistler (1834–1903). Whistler spent fourteen months in Venice, beginning in September 1879, producing not only etchings, watercolors, and a few oils, but a great many pastel sketches. In Venice at this time, Twachtman saw the pastels and was much impressed with them. John Hale, who wrote his Ph.D. dissertation on Twachtman, believes that he probably first used pastels in 1885, but it seems clear that he could have started earlier. At the second exhibition of the Painters in Pastel (1888) he had eleven entries, being surpassed only by Robert Blum with thirty-one. The use of colored paper provided Twachtman (as it had Whistler) with a basic ground for his compositions. The wispy, sketchy quality so characteristic of Whistler's pastels is evident in Trees in a Nursery.

REFERENCE: John Douglas Hale, "The Life and Creative Development of John H. Twachtman," vols. I and II, Ph.D. dissertation, Ohio State University, Columbus, 1957, no. 1030.

EXHIBITED: Ira Spanierman, New York, 1968, *John Henry Twachtman, 1853–1902, an Exhibition of Paintings and Pastels*, no. 33.

EX COLL.: Martha S. Twachtman; Mr. and Mrs. Godfrey Twachtman; [Milch Gallery, New York, 1967].

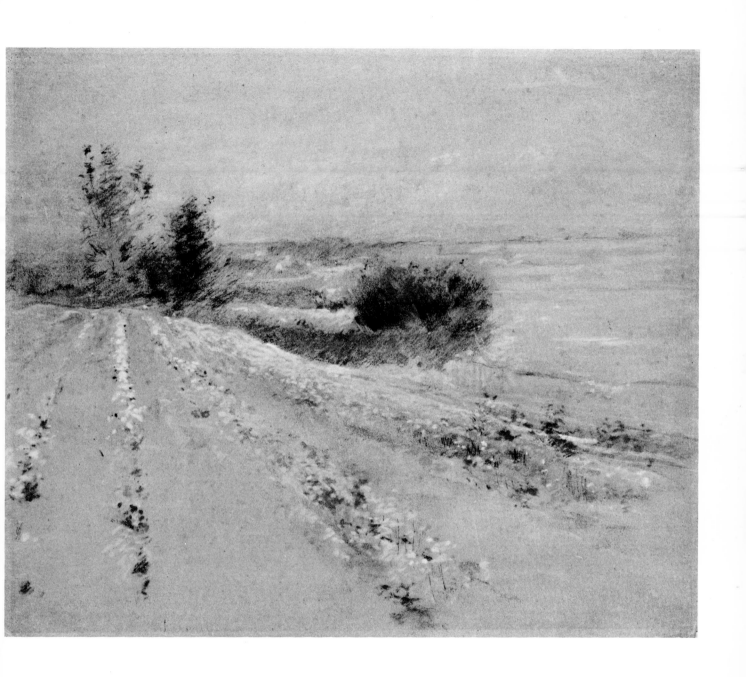

20 TWACHTMAN: Niagara Falls

Oil on canvas; 30 x 30 inches.
Stamped (lower right) with red oval of Twachtman sale; about 1894.

Despite the variety of technique in Twachtman's work, it shows an overriding consistency of spirit. Eliot Clark, in his book on Twachtman, called his approach "truly that of an artist." "Disdaining poetical associations," Clark writes, "he respected the reaction of his eye, not for its informing facts, but for its aesthetic sensibility. Therein he is related, not only to the dictum and practice of Whistler, but to the aesthetic doctrine of his time." In the early 1890s Twachtman was commissioned by Charles Carey of Buffalo to paint the Niagara Falls, and as a result of that commission came a request for a series on the Yellowstone Falls. He painted at least fourteen versions of Niagara; a view remarkably similar to this one, from the cave of the winds, appears in Allen Tucker's book. The Niagara paintings were first exhibited in 1894, and Twachtman must have continued for years to paint the scene from memory. He treats the power and grandeur of Niagara no differently from the way he depicts the small falls on his Greenwich, Connecticut, farm. His interest was in the abstract aspect of the image, not in the tremendous force of the water. Twachtman's work in this so-called "Greenwich" style differs considerably from the paintings he did in France. His palette began to lighten at about the time his friend Theodore Robinson started making periodic visits to the farm in 1889; the tenets of impressionism were, in this case, passed on by an American rather than a French artist. Twachtman developed an impasto technique that gives the painting the appearance of being dry and chalky, similar to the effects of pastel. He preferred to paint the diffused light of a hazy day or the snow of winter rather than the crisp delineations of a bright, clear afternoon. Like Monet, Twachtman painted the same subject repeatedly, not to record the changing effects of light but to convey his emotional response to the prevailing conditions.

REFERENCES: Eliot Clark, *John Twachtman*, New York, 1924; Allen Tucker, *John H. Twachtman*, New York, 1931, no. 28, ill.

EXHIBITED: Albright-Knox Art Gallery, Buffalo, New York, 1964, *Three Centuries of Niagara Falls*, no. 51; Metropolitan Museum, 1966, *Summer Loan Exhibition: Paintings, Drawings, and Sculpture from Private Collections*, no. 187.

EX COLL.: American Art Galleries, New York, 1903, John H. Twachtman sale, no. 98, to F. Henderson, New Orleans, La.; Sylvester W. Labrot, Jr., Hobe Sound, Fla.; [M. Knoedler & Co., New York, 1964].

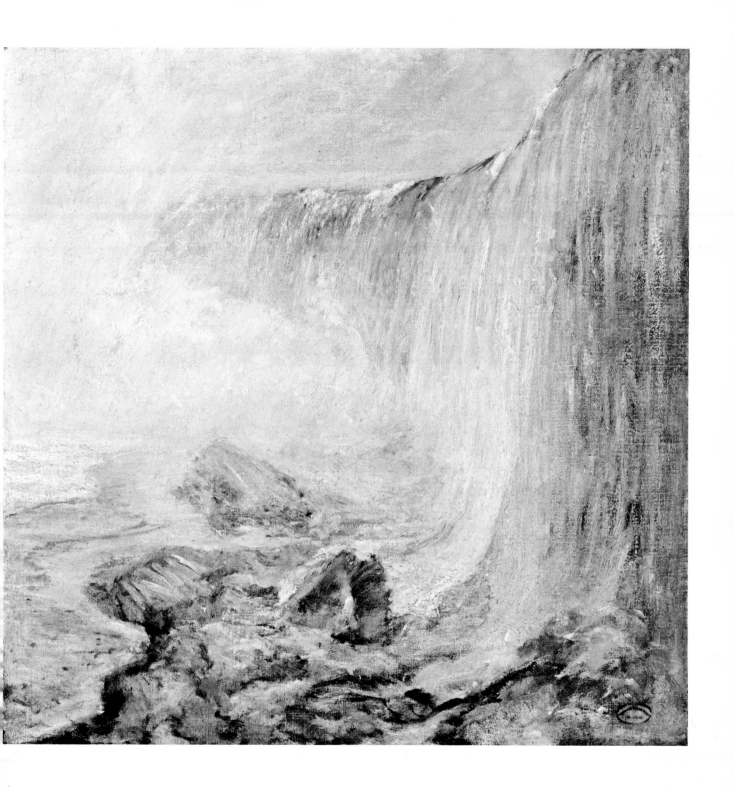

21 TWACHTMAN: Waterfront Scene—Gloucester

Oil on canvas; 16 x 22 inches.
Signed (lower left): JH Twachtman; about 1901.

During the last years of his life Twachtman began to change his style. As some have suggested, it was as if he knew his time was short, for he painted more quickly and directly than before. His color became brighter, although still well within the pastel range. Starting in 1900 he summered in Gloucester, Massachusetts, taking great delight in the activities of the harbor. In this view of the waterfront he seems to have recaptured the exhilaration of his youth in his exuberant handling of paint and color. The picture surface is alive with activity, unlike any of his paintings before. In the past, whether it was the thin washes of his French paintings or the thick impasto of his 1890s work, he had subordinated the technique in order to emphasize the forms and overall design. Here he has a more impressionistic approach. There is the excitement of experimentation, as if he were entering into a new consciousness and expressing himself in it.

REFERENCE: John Douglas Hale, "The Life and Creative Development of John H. Twachtman," vols. I and II, Ph.D. dissertation, Ohio State University, Columbus, 1957, no. 688, ill. fig. 142.

EXHIBITED: Metropolitan Museum, 1966, *Summer Loan Exhibition: Paintings, Drawings, and Sculpture from Private Collections,* no. 188; Ira Spanierman, New York, 1968, *John Henry Twachtman, 1853–1902, an Exhibition of Paintings and Pastels,* no. 23 (as Gloucester).

EX COLL.: Son of W. A. Putnam; Mr. and Mrs. Allen T. Clark; [Ira Spanierman, 1966].

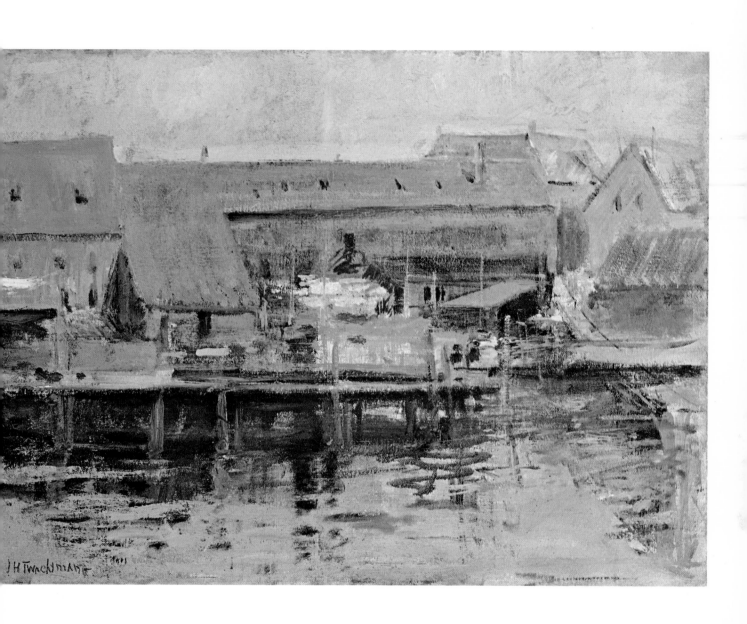

JULIAN ALDEN WEIR

1852-1919 Weir, ultimately an early exponent of impressionism, illustrates the American disinclination to accept the new style. Born in West Point, New York, he received his first art instruction from his father, Robert, who taught drawing for many years at the U.S. Military Academy. After three years at the National Academy of Design in New York, Weir entered the Ecole des Beaux-Arts in 1873 and studied under Gérôme. From the beginning, nature was the stimulus he needed. He had no patience with copying from the antique. "To me," he remarked, "there are no rules except those which your own feelings suggest, and he who renders nature to make one feel the sentiment of such, to me is the greatest man." His words explain his devotion to the French plein-air artist Bastein-Lepage. Moral seriousness permeated Weir's life and work, and he felt that decadence in art begins with too much freedom. It is not surprising, then, that when he first encountered a group of impressionist paintings in 1877, he called the exhibition a "Chamber of Horrors." He was to remain unreceptive to the movement until his own work began to change in the early 1890s. It was only Manet's paintings that he felt "spoke the language of principles, not merely fashion." In 1881, upon the advice of his friend Chase, Weir bought Manet's Woman with a Parrot and Boy with a Sword, both now in the Metropolitan Museum, for Erwin Davis's collection. The year before he had purchased Bastien-Lepage's Joan of Arc (also in the Metropolitan), the sensation of the 1881 Society of American Artists exhibition. After several trips through Europe, Weir settled in New York in 1883. His work of this period was dark and solidly constructed. Weir was active in the foundation of the Society of American Artists in 1877 and the Ten American Painters in 1898.

22 WEIR: U.S. Thread Company Mills, Willimantic, Connecticut

Oil on canvas; 20 x 24 inches.
Signed (lower left): J. Alden Weir; about 1893–1897.

Weir's exhibition at the Blakeslee Galleries in January 1891 marked a new phase in his development. His paintings were now lighter and freer, and his response to nature was more expansive. "Painting," he wrote, "has a greater charm to me than ever before and I feel that I can enjoy studying any phase of nature which before I had restricted to preconceived notions of what it ought to be." In May 1893 the American Art Galleries arranged a joint exhibition comparing the work of Monet and Besnard to that of Twachtman and Weir. Also that year Twachtman and Weir exhibited at the St. Botolph Club in Boston. It is hard to imagine now that Weir was considered an extremist in the impressionist movement, particularly when we look at this quite conventional scene. In 1893 he began a series of five or six paintings of the factory buildings in Willimantic, Connecticut, near where he summered. Four other versions are known: Thread Mills, 1893; Willimantic Thread Mills, 1893, the Brooklyn Museum; The Factory Village, 1897, collection of Mrs. Charles Burlingham; and Willimantic, 1897. Industrial scenes were hardly considered proper subject matter for artists in the 1890s, yet it is not surprising that Weir chose to paint them. His older brother John had already produced the dramatic pictures of The Gun Foundry (1866) and Forging the Shaft (1867). J. Alden Weir's paintings make no social comment but rather delight in their views of buildings, bridges, landscape, and sky. Stylistically this painting is more closely related to the 1893 version in the Brooklyn Museum than to the more mature work of The Factory Village of 1897, which Weir proudly exhibited in the first show of the Ten American Painters in 1898. Weir's work has an underlying consistency of form and restraint but, at the same time, a warmth in its subtle color harmonies. Oliver Larkin, in *Art and Life in America* (1949), aptly called him a man "who never bragged in paint."

EXHIBITED: Wickersham Gallery, New York, 1965, *American Paintings*, no. 7, ill.

EX COLL.: Wickersham June to Robert Carlen to [Schoelkopf Gallery, New York, 1968].

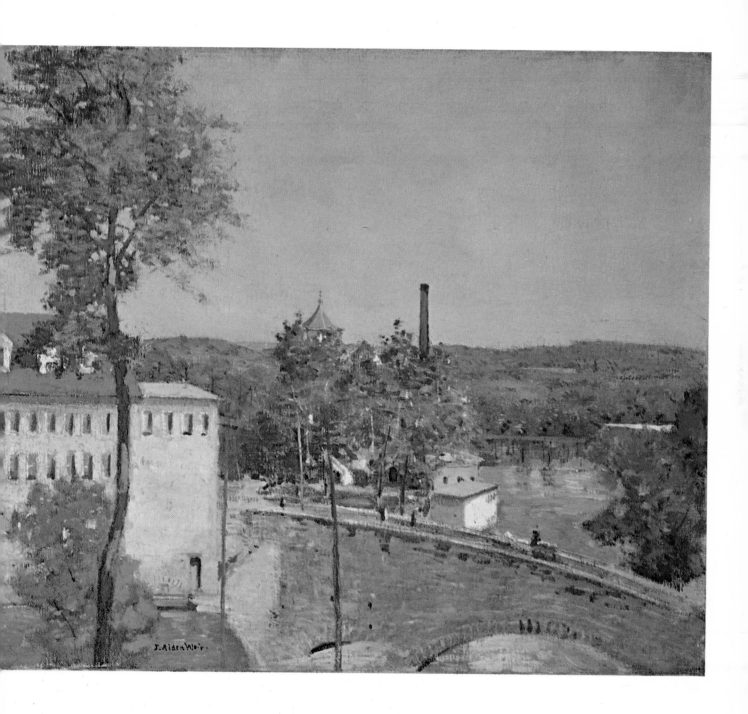

THOMAS WILMER DEWING

**1851-
1938**

The idealization of women became a popular late-nineteenth-century theme, particularly in the United States. It was so popular that Europeans began to regard it as something uniquely American. Within this theme, Thomas W. Dewing created his own vision of the world, a world where women drift idly in meditation through bare rooms or on grassy slopes. The youngest of five children, Dewing was born in Boston. He studied at the Boston Museum Art School and painted portraits for a year or two in Albany before going to Paris in 1876. Like so many of his contemporaries, he entered the Academy Julian under the tutelage of Boulanger and Lefebvre. Dewing returned to America in 1879 and settled in New York. In 1881 he married Maria Oakey, a noted flower painter, and began to teach at the Art Students League. He had already been accepted into the Society of American Artists in 1880 and in 1888 was made a full academician of the National Academy of Design. In 1898 he became a founding member of the Ten American Painters. By the 1890s Dewing had developed a style that was uniquely his own. Many influences can be seen in it, particularly those of Vermeer and Whistler, but his work embodied a dreamlike quality, an almost surreal approach not seen in the paintings of most of his contemporaries. His women, never more than three, except in his decorative work, are slim and sleek, detached and cool. They appear intelligent and even quizzical. But as one critic said, they "can do nothing and do it beautifully." The Dewing interior or landscape is always sparse, and, perhaps because of his love of the theater, it is also stagelike. The interest in the colonial revival, which had been encouraged by Dewing's friend Stanford White in the 1880s, is seen in his use of simple, eighteenth-century New England furniture. The influence of Japanese prints is obvious in the abstract and asymmetrical arrangement of figures and furnishings. Most contemporary writers likened his sense of proportion and form to harmony and counterpoint in music. He used few colors, usually repeating a single tone to produce an intimate atmosphere that envelops his figures. Charles H. Caffin wrote of Dewing's work: "The figures, even the accessory objects, seem to be detached from ordinary usage and suggestion. They live apart, in a medium of their own; they are no longer personal, individual; they are not figures and objects; they are Presences."

23 DEWING: Portrait of a Lady

Pastel on paper; 14½ x 11¼ inches.
Signed (lower right): T. W. Dewing/(140); inscribed (back of paper): Pastel
140/T. W. Dewing; pasted to back of paper: William Macbeth Gallery label.

Dewing's work is difficult to date because of its unchanging character. He lived to be
eighty-seven and continued to paint until about ten years before his death. This
pastel, numbered 140, illustrates the problem of chronology, for it would appear to
have been done in the late 1890s; yet, according to Dewing's notes, pastel no. 130
was not done until March 20, 1923. (Dewing numbered his pastels in order to keep
track of those he sold.) The style and costume here are of an earlier period. How-
ever, he kept an assortment of evening gowns in his studio, saved from his days as a
portrait painter, and they appear throughout his work. His drawing skill and subtle
simplicity are especially evident in his pastels. Nelson C. White, writing about
Dewing said: "His pastels of single figures are elusive and subtle. They are like the
wings of some exquisite butterfly, or the petals of some softly colored flower. They
are never fragmentary; they are wonderfully complete, but also mysterious and
suggestive."

REFERENCE: Graham Williford, Letter to D. H. P., 3 Sept. 1972.

EX COLL.: Mrs. Don B. Myers; [James Graham & Sons, New York, 1969].

78

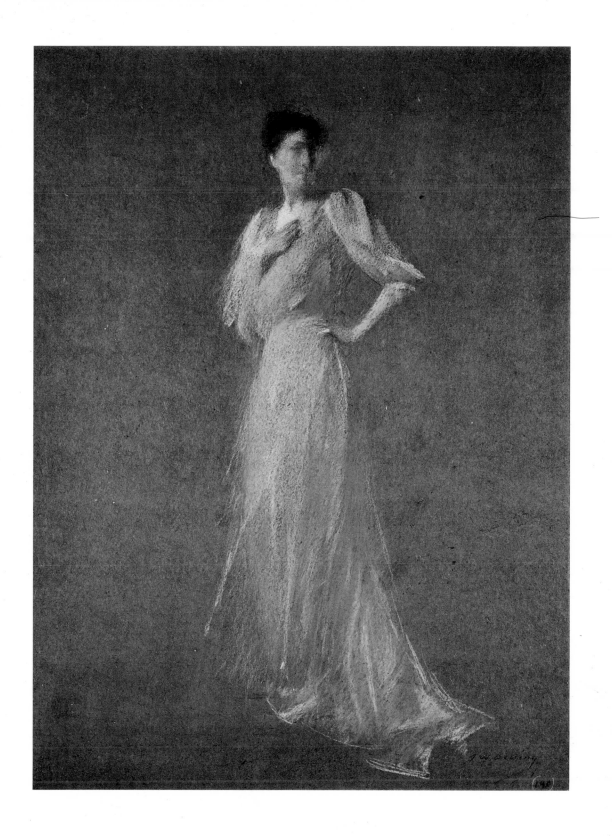

CHILDE HASSAM

1859-1935 One of America's most successful impressionist painters, Frederick Childe Hassam was born in Dorcester, Massachusetts. A descendant of English settlers who arrived in that state in the seventeenth century, Hassam always retained a strong attachment to New England. A successful merchant, his father began collecting American antiques long before there was a renewed interest in such things. At an early age Hassam signed his paintings "F. Childe Hassam," but soon dropped the Frederick completely. With his aptitude for drawing he went to work for a wood engraver, designing and cutting blocks. He soon established himself as an illustrator and before long was contributing to such magazines as *Harper's, Scribner's,* and *Century.* In the evenings he attended life drawing classes at the Boston Art Club. His interest in painting may have stemmed from his studies with a young German artist, Ignaz Manuel Gaugengigl. Through the influence of a group of landscape painters, also at the Boston Art Club, he began doing plein-air landscapes of the Boston environs. Even before his major trip to Europe, from 1886 to 1889, his paintings show an interest in the effects of atmosphere and light. For three years he attended the Academy Julian in Paris, developing his technical facility. At the same time he was taking note of the experiments of the impressionists, who were at the height of their popularity. When Hassam returned and settled in New York he was an avowed impressionist. His bustling street scenes and picturesque views of New England won him many awards and a great deal of popularity. Like the French impressionists, he often did a series on one subject, like the craggy rocks on the Isles of Shoals or his paintings of Fifth Avenue, then called the "Avenue of the Allies," done between 1916 and 1918. He was one of the organizers of the Ten American Painters in 1898. His profound interest in promoting American art was demonstrated at the time of his death; he bequeathed all his remaining pictures to the American Academy of Arts and Letters with the provision that they be sold to establish a fund for the purchase of works by American and Canadian artists, which would then be donated to museums.

24 HASSAM: Nurses in the Park

Oil on wood; 9¾ x 13¼ inches.
Signed (lower left) : Childe Hassam; about 1889.

Hassam's Paris work, from 1886 to 1889, vacillates between tight academic drawing, influenced by teachers like Boulanger and Lefebvre, and the lighter, rainbow palette and fuller brushstroke of the impressionists. He was still interested, as he had been in Boston, in the atmospheric effects on gray, rainy days. As early as 1887 his painting Grand Prix Day (Museum of Fine Arts, Boston) looked forward to his more mature work. The scene here is Parc Monceau in Paris. Another version, in the J. William Middendorf collection, is larger and somewhat different in composition and color, but the two are identical stylistically. Monet painted several views of this same park in the late 1870s. One, called Parisians Enjoying the Parc Monceau, 1878 (Metropolitan Museum), was shown at the Galerie Georges Petit in 1889 and may have been seen by Hassam. His technique is very similar to Monet's in its broad, thick, slashing brushstrokes in the foreground contrasted with a more restrained handling of the figures and background landscape. Hassam belongs to a small group of American artists who returned from Europe with a fully developed impressionist style. Most contemporary artists were either unaffected or resisted the revolutionary events that occurred while they were in Europe, and it was not until they returned home that they developed an interest in the new style. Hassam's later work becomes more formalized and somewhat mannered in its pointillist style, losing the vitality and freshness of his earlier paintings.

REFERENCES: Metropolitan Museum, *American Paintings and Historical Prints from the Middendorf Collection,* New York, 1967, no. 51, p. 62; *Los Angeles Times,* 23 April 1972, ill., p. 54.

EXHIBITED: Corcoran Gallery of Art, Washington, D.C., 1965, *Childe Hassam, a Retrospective Exhibition,* no. 11 (traveled to Museum of Fine Arts, Boston; Currier Gallery of Art, Manchester, N. H.; Gallery of Modern Art, New York); Metropolitan Museum, 1968, *New York Collects: Paintings, Watercolors, and Sculpture from Private Collections,* no. 74; University of Arizona Museum of Art, Tucson, 1972, *Childe Hassam, 1859–1935,* no. 30, ill. p. 68.

EX COLL.: John Fox, Boston; Dwight W. Collins, Washington, D.C.; Babcock Galleries, New York; [Davis Galleries, New York (on consignment from Babcock Galleries), 1961].

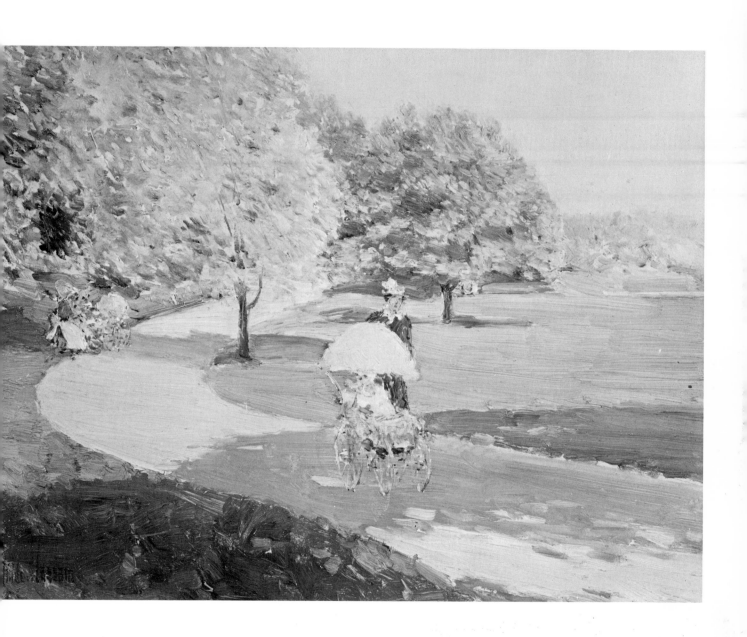

25 HASSAM: Poppies, Isles of Shoals

Pastel on brown paper; 7¼ x 13¾ inches.
Signed and dated (lower left): Childe Hassam 1890.

The Isles of Shoals, off the coast of New Hampshire, were a favorite summer retreat for Hassam, both before his trip to Europe in 1886 and after. "Hassam never wearied of his voyages of discovery among the Isles of Shoals," his biographer, Adeline Adams, wrote. "To him they were as the isles of Greece, with the added charm and tingle of the New England sea, sky and air; not only the air you breathe for physical delight, but the atmosphere with its illimitable ranges and changes from near to far, its lovely flight of tones from burning opal to dim pearl." Mrs. Celia Thaxter, a writer and patron of artists and writers, had a home on Appledore, considered the most beautiful of the nine islands. She and Hassam had been close friends since the days when she studied watercolor painting with him in Boston. The two collaborated on a book entitled *An Island Garden,* published in 1894. Hassam created glorious color illustrations to enhance her description of the garden she had cultivated since the age of five. Mrs. Thaxter wrote: "I think for wondrous variety, for certain picturesque qualities, for color and form and a subtle mystery of character, Poppies seem, on the whole, the most satisfactory flowers among the annuals. There is absolutely no limit to their variety of color." One of the illustrations, "From the Doorway," shows a bed of poppies with the ocean and sky in the distant background; there are a number of horizontal paintings of the same subject, which in turn relate to this pastel. Although this version is freer and more sketchy than the paintings, Hassam has captured the vibrant colors of the poppies and the naturalness of Mrs. Thaxter's garden.

EX COLL.: Milch Gallery, New York; John Fox, Boston; [Babcock Galleries, New York, 1962].

WILLARD LEROY METCALF

**1858-
1925**

Metcalf painted the New England countryside in its various moods according to the changing seasons. He was born in Lowell, Massachusetts, where he received his early education. At seventeen he was apprenticed to a wood engraver and in 1876 entered the studio of George L. Brown, while attending life drawing classes at the Lowell Institute. He continued his art education at the Massachusetts Normal Art School and the school of the Museum of Fine Arts, Boston. To support himself he turned to illustration and in 1881 traveled to the Southwest with Frank A. Cushing of the Smithsonian Institution to illustrate a series of articles on the Zuni Indians. In 1883 he went to Paris and studied at the Academy Julian under Boulanger and Lefebvre. He received an honorable mention in the Paris Salon of 1888. Little is known about his six years abroad, except that he spent the summer of 1887, along with Theodore Robinson, at Giverny, the home of Claude Monet. When he returned to Boston in 1889 he had an exhibition at the St. Botolph Club, in which he showed landscapes of France and of Tunis and Biskra. Metcalf soon moved to New York and taught at the Art Students League and at the Cooper Institute. He had become a member of the Society of American Artists in 1887 but withdrew in 1898 to join the Ten American Painters. Metcalf enjoyed success both as a painter and as an illustrator. In 1903 he left New York for a year to paint along the Damariscotta River in Maine. From that time on he devoted himself solely to painting the landscape of his beloved New England.

26 METCALF: The Jetty

Pastel on paper; 6½ x 8¾ inches (sight).
Signed (lower left): W. L. Metcalf; about 1895.

The influence of the French impressionists, and of Claude Monet in particular, is evident in this light-filled work. The scene is doubtless Gloucester, Massachusetts, a summer resort popular with artists. In 1895 Metcalf did an oil painting entitled Gloucester Harbor, in which this same jetty can be seen with an almost identical three-masted ship in the harbor beyond. The Jetty illustrates the impressionist's love for arbitrarily cutting off pictorial elements at the picture's edge, for the casual and asymmetrical composition, and for the brilliance of the sun and its effect on land and sea. Metcalf has captured the ocean breeze as it slowly pushes the schooner through the water, and rustles the skirts of the figures on the wharf.

REFERENCE: *New York Times*, Review of *Quiet Moments in American Painting, 1870–1920*, 14 Dec. 1963.

EXHIBITED: Wickersham Gallery, New York, 1963, *Quiet Moments in American Painting, 1870–1920*, no. 6.

EX COLL.: [Wickersham Gallery, 1963].

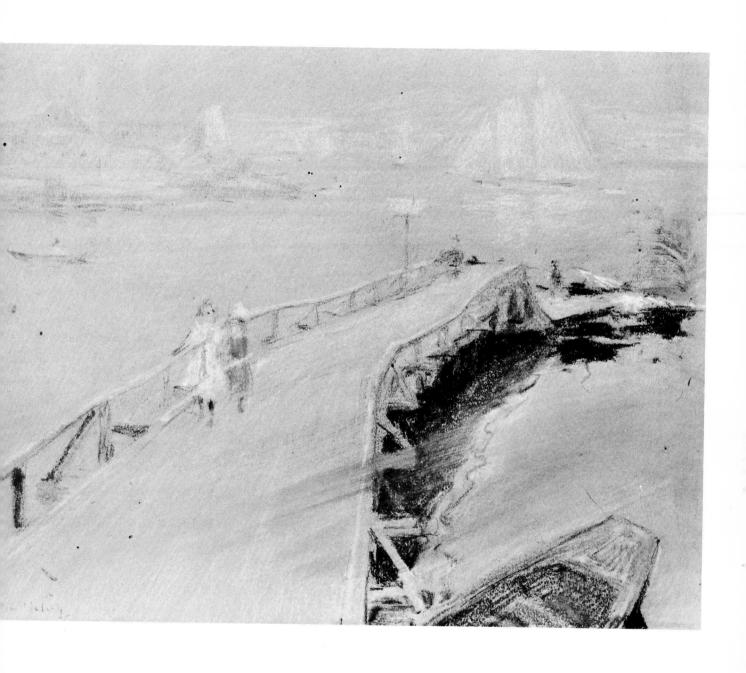

EDMUND CHARLES TARBELL

1862-1938

Tarbell was the central figure in a group of Boston artists including Frank W. Benson, Joseph De Camp, Philip Leslie Hale, and before they left for New York, Childe Hassam and Willard Metcalf. He was born in West Groton, Massachusetts. His father, a ship designer, was also gifted in drawing and painting. The young Tarbell was an indifferent student. At fifteen he was apprenticed to the Forbes Lithographic Company; later he considered the three years he spent there the best artistic start he could have had. In 1879 he enrolled in the school of the Museum of Fine Arts, Boston, working under Otto Grundmann. After graduating, Tarbell was drawn to Paris, the artistic mecca at a time when impressionism was triumphant. But like his compatriots he studied under the academic painters, Boulanger and Lefebvre, at the Academy Julian. Before returning to America in 1888 he traveled to Germany and Italy, spending a winter in Venice. From 1889 until 1913 he was an instructor in drawing and painting at the school of the Museum of Fine Arts in Boston. In 1891 he and his lifelong friend Frank Benson had their first exhibition at the St. Botolph Club. Tarbell did a number of large plein-air canvases, such as In the Orchard (National Collection of Fine Arts, Washington, D.C.), which suggests that he must have seen Renoir's Luncheon of the Boating Party (Phillips Memorial Art Gallery). In 1886 he had joined the Society of American Artists, but in 1898 he broke away to become a member of the Ten American Painters. He left Boston in 1918 to become principal of the Corcoran School of Art in Washington, D.C. In 1926 Tarbell retired to his summer home in New Castle, New Hampshire.

27 TARBELL: Woman in Pink and Green

Oil on canvas; 48 x 36⅛ inches.
Signed and dated (lower left): Edmund C. Tarbell/97.

Aside from his many outdoor paintings in the bravura brushwork technique characteristic of the American impressionists, Tarbell also painted a great many portraits. Late in the 1890s his paintings began to show the influence of Vermeer; he concentrated on interiors with soft, filtered light, in which women go quietly about their daily chores. He became famous for these intimate scenes of his family and friends. Woman in Pink and Green shows his daughter, Josephine Tarbell Ferrell, as the central figure with a parasol; his mother, Mrs. Hartford, in a white cap, and his wife, Emeline, are seated in the corner. These simple interior views may have appealed to Tarbell for many reasons. They allowed him to pursue his interest in light and atmosphere without sacrificing the solidity or character of the objects themselves, a sacrifice which seemed, in the eyes of many Americans, to be too great in the outdoor paintings of the French impressionists. An interior space was also a perfect vehicle for his mastery of the arbitrary placement of pictorial elements, patterns, texture, and subtle color tonalities, newly learned techniques inspired by Whistler, Japanese prints, and the impressionists.

REFERENCES: Lorinda M. Bryant, *What Pictures to See in America*, New York, 1915, pp. 305–306, ill. opp. p. 306; Cincinnati Museum Association, *Catalogue of the Permanent Collection of Paintings*, 1919, no. 183; Lorinda M. Bryant, *American Pictures and Their Painters*, London, 1921, pp. 184–185, ill. fig. 139.

EXHIBITED: *La Biennale di Venezia*, 1897; Durand-Ruel Galleries, New York, 1898, *Ten American Painters*, no. 29; Art Association of Indianapolis [Indiana], John Herron Art Institute, 1908, *24th Annual Exhibition*, no. 56; St. Louis City Art Museum, 1912, *7th Annual Exhibition of Selected Paintings by American Artists*, no. 105, ill. opp. p. 17; Museum of Fine Arts, Boston, 1938, *Frank W. Benson–Edmund C. Tarbell, Exhibition of Paintings, Drawings, and Prints*, no. 195; Metropolitan Museum, 1966, *Summer Loan Exhibition: Paintings, Drawings, and Sculpture from Private Collections*, no. 178; Metropolitan Museum, 1968, *New York Collects: Paintings, Watercolors, and Sculpture from Private Collections*, no. 216; Metropolitan Museum, 1970, *19th-Century America, Paintings and Sculpture*, no. 201.

EX COLL.: Artist to Cincinnati Art Museum, 1898–1945; [Victor Spark, New York, 1965].

FRANK WESTON BENSON

**1862-
1951**

Benson's name is so closely associated with that of Edmund Tarbell that the Museum of Fine Arts, Boston, had a joint exhibition of their work in 1938. He was born, the same year as Tarbell, in Salem, Massachusetts. He enrolled in the Boston museum's art school in 1880, studying with Tarbell under Otto Grundmann. In Paris from 1883 to 1885, he studied at the Academy Julian under Boulanger and Lefebvre. When he returned to America he began to paint portraits. Before teaching at the art school of the Museum of Fine Arts, Boston, in 1889, he taught drawing and painting in Portland, Maine. From the 1890s onward, Benson received many awards and honors. He was a member of the then-avant-garde Ten American Painters. An avid huntsman and lover of the out-of-doors, Benson began a series of etchings in 1912 depicting flying game birds, hunters, and fishermen. These themes, in oil, watercolor, and etching, occupied him for the rest of his career.

28 BENSON: Summer Day

Oil on canvas; 36⅛ x 32⅛ inches.
Signed (lower right): F. W. Benson; about 1911.

It is interesting to compare the work of Benson and Tarbell. In the early 1890s Tarbell was interested in plein-air, impressionist paintings, but he slowly withdrew to interior scenes which were to become his forte. Benson, on the other hand, painted interior views with women in the early nineties but eventually became intrigued with the effects of outdoor luminosity on figures and the beauty of the sea and sky. His skill was in rendering the dazzling effects of direct sunlight and combining a sort of casual portraiture with landscape. Every summer he went to North Haven Island in Penobscot Bay, Maine, where his wife and children often served as models for his shimmering outdoor canvases. His technique is painterly and spontaneous, like many of the American artists who were influenced by French impressionism. His work is joyous and carefree, filled with young women at leisure, the same sort of young women who people Tarbell's interiors.

EXHIBITED: Pennsylvania Academy of the Fine Arts, Philadelphia, 1912, *107th Annual Exhibition*, no. 619, p. 55, ill. opp. p. 12; Cincinnati Art Museum, 1912, *19th Annual Exhibition of American Art*, no. 2, p. 7, ill.; Metropolitan Museum, 1968, *New York Collects: Paintings, Watercolors, and Sculpture from Private Collections*, no. 4.

EX COLL.: [Ira Spanierman, New York, 1968].

96

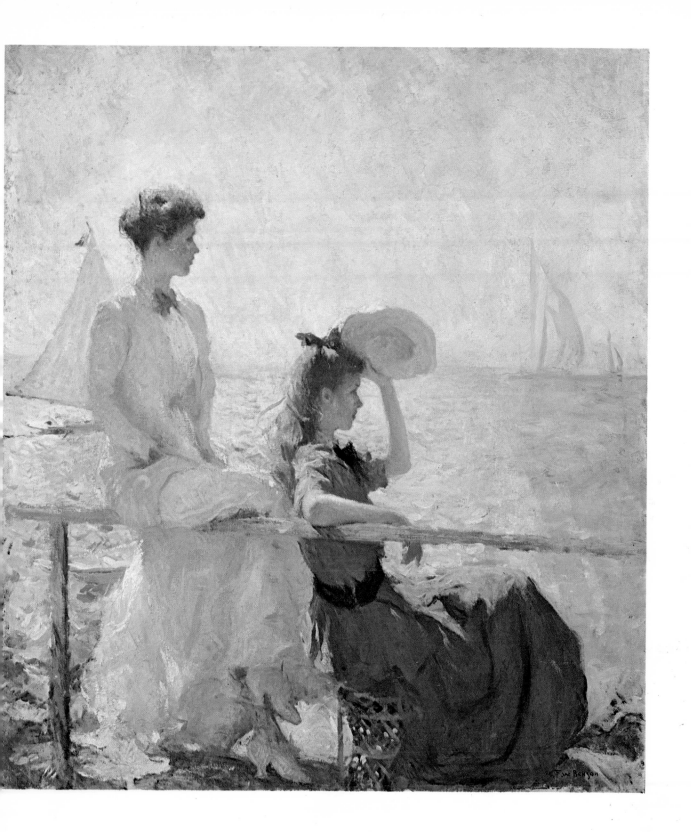

MAURICE PRENDERGAST

Prendergast developed a highly personal, impressionistic style that looked forward to the modern art of twentieth-century America. His style evolved from an impressionist's concern with natural appearances and the temporary effects of light and atmosphere to a purely subjective, emotional response to color. He was one of the first Americans to be influenced by the French post-impressionists and to disregard a strictly representational approach to art. Born in St. John's, Newfoundland, he grew up in Boston with his younger brother and steady companion, Charles. His formal education finished at fourteen, Maurice was apprenticed to a painter of show cards. By the age of twenty-four he was supporting himself with this work and in his spare time sketching landscapes in Day's Woods. Charles said of his brother: "Monny [Maurice] had the right idea. He knew he wanted to be an artist right from the start, and he didn't let anything stand in his way." In 1886 the brothers worked their way to England on a cattle boat and Maurice may even have visited Paris for a short time. Not until 1891 did he have sufficient money for prolonged study in Paris. He began with Courtois at Colarossi's, but soon joined the life class at the Academy Julian under Constant, Blanc, and Jean Paul Laurens. Until this time the human figure was almost absent from his work; now the life of the French boulevards fascinated him, and he began to sketch this activity. A Canadian artist, James Wilson Morrice, and his circle of friends were largely responsible for Prendergast's development in choice of subject and approach. In the Paris milieu he was exposed to Whistler, Manet, Degas, Toulouse-Lautrec, Cézanne, Gauguin, and the Nabis, particularly Pierre Bonnard. It was the post-impressionists who fired his imagination and eventually led him to his own singular style. During the mid-nineties Prendergast returned to America and began to enjoy some mild success. He received a commission to illustrate James Barrie's *My Lady Nicotine*, published in 1896. An exhibition of his work in 1897 drew the attention of Mr. and Mrs. Montgomery Sears, and with their help he was able to work in Europe the next two years, most of the time in Venice. Here he discovered Carpaccio, the Renaissance artist who shared his own love for crowds and pageantry. Under this stimulus his work became more solid, his color warmer and more opaque. He exhibited as one of The Eight in 1908 and in the Armory Show, 1913.

29 PRENDERGAST: Revere Beach

Watercolor on paper; 14 x 10 inches.
Signed and dated (lower right): Prendergast 1896.

Late in 1894 or in early 1895 Prendergast, impecunious and nearly deaf, returned to America an accomplished watercolorist. Although he did paint a few oils during this period, he preferred watercolor. The theme of bustling crowds in pursuit of relaxation was now his favorite and occupied him throughout his life. From 1895 until 1898 he painted people at play or going about their everyday affairs, either in Boston or along the coast. Some of his favorite spots were Revere Beach, Beachmont, Marblehead, and South Boston Pier. He did several versions of Revere Beach in the same free, direct style of his Paris watercolors, but with a whimsical, almost naive quality that was new.

REFERENCE: Sotheby, Parke-Bernet Galleries, *Traditional and Western American Paintings, Drawings, Watercolors, Sculpture & Illustrations of the 18th, 19th, and Early 20th Centuries*, New York, 1972, no. 10.

EXHIBITED: University of Connecticut, Museum of Art, Storrs, 1969 (loaned, May–Dec.).

EX COLL.: Edgar W. Hodgson to Carolyn Holdtman; [Sotheby, Parke-Bernet Galleries, 1972].

30 PRENDERGAST: Picnic, Boston Garden

Watercolor and pencil on paper; 8¾ x 16⅝ inches.
Signed (lower right): Prendergast; inscribed (back of paper):
Picnic 1895–97 (Boston Garden).

Though done about the time of Revere Beach, this watercolor sketch is stylistically very different. It shows the influence of Prendergast's monotypes, which he did between 1892 and 1905. It may have been a study for a monotype, or, as Hedley Howell Rhys writes, "Subjects and compositions developed by Maurice in [monotype] were often used in watercolors and oils." Whatever its sequence, although it is most probably a study for a print, this drawing demonstrates the influence of Bonnard. Here Prendergast's watercolors were applied in broad, flat strokes, as was his way in the monotypes. Traditional perspective is used in Revere Beach, but here the space becomes two-dimensional. As in the monotypes, there is a border around the framing edge, which includes at the top what appear to be figures off in the distance. The color is low-keyed and subtle, as in the monotypes, and quite unlike the clearer, brighter colors of Revere Beach.

EXHIBITED: Brooklyn Museum, 1964, *American Painting, Selections from the Collection of Daniel and Rita Fraad,* no. 34, ill. p. 43 (as Picnic, Central Park, 1903).

EX COLL.: Mrs. Charles Prendergast; [Davis Galleries, New York, 1962].
Owned jointly with Mr. and Mrs. Daniel Fraad, Jr.

102

31 PRENDERGAST: The Breezy Common

Monotype; 10⅜ x 8¼ inches.
Signed on plate (lower right): Prendergast; (lower left):
The Breezy Common; inscribed (back of print): The Breezy
Common—1901/M. Prendergast.

Prendergast produced as many as two hundred monotypes between 1892 and 1905. Although he possibly knew of Degas's work in this medium, it is not known what inspired this activity or why it stopped. Most of his work was printed by hand and done with oil paint on glass or metal. Prendergast's own description of his method was: "Paint on copper in oils, wiping parts to be white. When picture suits you, place on it Japanese paper and either press in a press or rub with a spoon till it pleases you." Many of the prints are signed or initialed and titled on the plate, as this one is. Certain subjects, like the circus, were treated only in this medium; he did many variations on a single theme. The Breezy Common is related to Lady in Pink Skirt (collection of Mrs. Charles Prendergast), which shows an almost identical central figure with a child to the left and numerous figures in the background. But, unlike this version, it does not have the child on the woman's right. (There is also a monotype with the same title in the collection of Dr. and Mrs. Irving Levitt.) The movement of women's skirts was a favorite Prendergast subject. According to Van Wyck Brooks: "When short skirts came into fashion, after [Prendergast] had settled in New York, he spoke of the beautiful movement that women had made when, at a street-corner, they turned round to lift up their skirts before they scurried across the street. 'That's a lost art,' he said."

EXHIBITED: Davis Galleries, New York, 1963, *Drawings by Maurice B. Prendergast*, no. 40; William Cooper Procter Art Center, Bard College, Annandale-on-Hudson, New York, 1967, *Maurice Prendergast, The Monotypes*, no. 29.

EX COLL.: Mrs. Charles Prendergast; [Davis Galleries, 1962].

104

32 PRENDERGAST: Picnic by the Inlet

Oil on canvas; 28¼ x 24⅝ inches.
Signed (lower left): Prendergast; 1916.

Although watercolor was still his favorite medium, Prendergast began to take a more serious interest in oil about 1903 or 1904. By 1907 his style was becoming more decorative and abstract. His oils were applied in such a way that the figures and the background were given equal attention, creating an overall pattern. He began to move away from what was then considered conventional reality. When he showed in the exhibition of The Eight in 1908, the critics reacted with "artistic tommy-rot, unadulterated slop, the show would be better if it were that of The Seven rather than The Eight." The period between 1909 and 1914 was a time of intense experimentation with new techniques and subject matter. A trip to France in 1909–1910 exposed him to the work of Signac. Ignoring Signac's theoretical use of color, he created an intuitive, highly personal mosaic effect. K. X. Roussel influenced him with his interest in pagan mythology and his use of heavy impasto. Working on the New England coast every summer, Prendergast would paint in watercolor the subjects which would become, in the winter, the basis for his oils. The paintings of his later years, such as this one, weave a lifetime of experimentation and memories into a magical poetry. His figures become larger and longer, mannered and static. A tapestry effect is created by his use of richer, deeper color broken into textured patterns. There is a mixture of sophistication and naïveté in these images of festive idleness that is both spiritual and sensuous.

REFERENCE: Hedley Howell Rhys, *Maurice Prendergast, 1859–1924,* Cambridge, Mass, 1960.

EXHIBITED: Metropolitan Museum, 1966, *Summer Loan Exhibition: Paintings, Drawings, and Sculpture from Private Collections,* no. 140; Metropolitan Museum, 1967, *Summer Loan Exhibition: Paintings from Private Collections,* no. 82.

EX COLL.: Estate of the artist; Mrs. Charles Prendergast; [Babcock Galleries, New York, 1965].

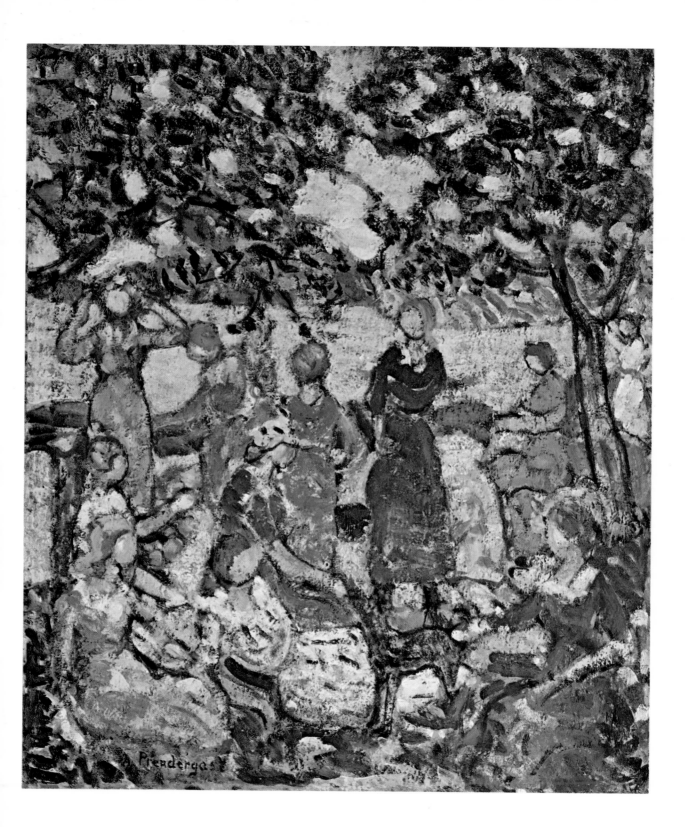

ERNEST LAWSON

1873-1939

Like his teacher Twachtman, Lawson was a landscapist and an impressionist. Upper Manhattan, the Palisades, and the Harlem and Hudson rivers were his favorite themes. Like Twachtman he preferred winter scenes with their muted and delicate pastel color range. Born in San Francisco, Lawson came to New York at age eighteen and studied at the Art Students League and at the Cos Cob summer school of J. Alden Weir and Twachtman. Influenced by the impressionist style of these two artists, Lawson left for Paris in 1893. The academic atmosphere of Julian's was too confining and he soon began to work on his own. He wrote of being impressed with some Whistlers he had seen and of being inspired by a meeting with Alfred Sisley. Although he saw Cézanne's first one-man exhibition, he was not to be influenced by the post-impressionists until after the Armory Show. By 1894 he was back in New York and off to Cos Cob again. His style at this time emulated Twachtman's misty luminosity. At about the turn of the century he moved to Washington Heights, at that time a semirural area, and began to paint his favorite subjects, the upper-Manhattan landscapes. When he moved to Greenwich Village some time later, he formed a lasting friendship with William Glackens, who introduced him to the rest of The Eight. Although he continued to paint more or less in the same style throughout his life, there were some changes in his technique. Richer color, described by one critic as "a palette of crushed jewels," and a greater solidity of form developed after his exposure to the post-impressionists. His biographers, Henry and Sidney Berry-Hill, suggest that the essence of Lawson was "his innate genius for impressionist landscape. When painting his earlier works, he handled his pigment with extreme delicacy, but there is never the feeling of anything fragile or contrived. Spiritually, he belonged to the immediate past and, while attuned to the generation of Armory Show painters, he was never disposed to nor was he able to diverge into any of the new avenues which art movements were taking."

33 LAWSON: Upper Harlem River

Oil on canvas; 16 x 20 inches.
Signed (lower left): E. Lawson; about 1915.

Despite the critics' reaction to the first exhibition of The Eight, all the artists in the group did not paint the dark, seamy side of life. The work of Arthur B. Davies, Prendergast, and Lawson was very different from that of Henri, Sloan, Glackens, Shinn, and Luks—the five Philadelphia realists. As the leader of the group, Henri was not interested in uniformity of style but in artists whose work was original and who were tired of the academic stranglehold. Henri admired Lawson's bold brushwork and unsentimental approach to impressionism. As in this case, Lawson often painted what were then considered unconventional subjects, such as squatters' huts, bridges, and railroads. In Upper Harlem River, Twachtman's influence is seen in the pearly luminosity of the scene, but the underlying structure and personal manipulation of the paint are Lawson's own. He applied his colors with a knife, brush, or even sometimes his thumb, creating a very heavy impasto. A sculptor, impressed with the solidity of Lawson's paintings, is said to have remarked about one of them, "If you don't mind, I should like to come around one day and make myself a cast of it." Today it is hard to imagine Lawson's work being considered radical, but the academic point of view—correct drawing, knowledge of anatomy, faithful rendering of color and form, and the proper theme—was still very much in the forefront when Upper Harlem River was new. Impressionism had been eagerly accepted by many American artists and collectors, but there was still an underlying conservative current, which remained steadfast well into the twentieth century.

REFERENCES: Henry and Sidney Berry-Hill, *Ernest Lawson—American Impressionist, 1873–1939,* Leigh-on-Sea, England, 1968, no. 71, ill.

EXHIBITED: Zabriskie Gallery, New York, 1962, *Ernest Lawson,* no. 9 (as Winter Scene); Metropolitan Museum, 1966, *Summer Loan Exhibition: Paintings, Drawings, and Sculpture from Private Collections,* no. 78.

EX COLL.: Robert Rockmore to [Zabriskie Gallery, 1962].

EDWARD HENRY POTTHAST

**1857-
1927**

Potthast's shyness and conservatism are revealed in his art. Although he is known for his dazzling impressionistic beach scenes, he did not begin to paint these until he was at least forty, after impressionism had finally gained popular acceptance. In his youth in Cincinnati, he worked as a lithographer and attended the McMicken School of Design. He studied and worked in Europe twice. About 1885 he studied with Charles Veriat in Antwerp and with Nicolas Gysis, Ludwig von Loefftz, and possibly Carl Marr in Munich. Late in the eighties he fell under the spell of the Barbizon landscapes and was introduced to French impressionism by the American artist Robert W. Vonnoh. In 1894 his Dutch Interior was purchased for the Cincinnati Art Museum. Settling in New York in 1896, Potthast worked for a number of years as a free-lance lithographer for *Scribner's* and *Century* magazines before devoting his full time to painting. By 1908 he had a studio in the Gainsborough Building overlooking Central Park, which he often painted. In his reserved fashion he seems to have mainly associated with other Cincinnati artists: Robert Blum, Frank Duveneck, John Twachtman, and William Jacob Baer. Summers, he painted on the New England coast. Along with four other artists, he was chosen in 1910 by the Sante Fe Railroad to paint the Grand Canyon.

34 POTTHAST: Beach Scene

Oil on wood panel; 11 x 15⅞ inches.
Signed (lower right): E Potthast; about 1915(?).

Before 1900 Potthast painted portraits in the brown tones of the Munich school. His landscapes show both the influence of the Barbizon painters and the fluid, broken brushwork of the impressionists. Possibly because of the success enjoyed by the Ten American Painters and the general acceptance of impressionism after the turn of the century, Potthast was inspired sometime between 1900 and 1903 to experiment with the new techniques. His landscapes began to radiate sunlight and vivid color, and he started to develop his favorite theme — groups of people relaxing at the beach. As with so many artists of his generation, his paintings are devoted to everyday experiences, presented in a casual and intimate way. The characters in Beach Scene are generalized and anonymous; Potthast does not tell a story or make a social comment; the charm of the painting is in the capturing of a moment. It is difficult to date Potthast's work, although the casualness of this composition and the spontaneity and thickness of the paint suggest that it was done after he had mastered his impressionist style.

EXHIBITED: Hirschl & Adler Galleries, New York, 1962, *Edward Henry Potthast, 1857–1927,* no. 19, ill., and on catalogue cover; Newark Museum, N.J., 1969, *Light and Atmosphere: American Impressionist Painters* (no catalogue); Whitney Museum of American Art, New York, 1972, *18th- and 19th-Century American Art from Private Collections,* no. 55.

EX COLL.: Mr. and Mrs. Merrill J. Gross to Hirschl & Adler Galleries to [M. Knoedler & Co., New York, 1964].

THOMAS POLLOCK ANSHUTZ

1851-1912

Through his teaching, Anshutz continued the realist tradition of Thomas Eakins. Since he was somewhat lost in the limelight of his master, his work and his influence have until recently been overlooked. Born in Newport, Kentucky, Anshutz began study at the National Academy of Design in New York when he was twenty-one. By 1876 he was studying at the Pennsylvania Academy of the Fine Arts and in 1881 was appointed assistant to Eakins in anatomy, drawing, and painting instruction. Even before his association with Eakins, he was inclined toward naturalism. Writing to his parents in about 1871, Anshutz had interpreted true painting as going outside and recording exactly what he saw: "If I can draw it well and color it as I see it and if I see well (which is the hardest part) my picture is true. . . . So my style now is painting and drawing what I see and I am an infant in it." Eakins's teaching method emphasized a thorough knowledge of anatomy and drawing from the living figure rather than from antique casts. His insistence on the use of nude male models in classes with women led to his dismissal in 1886, whereupon he was succeeded by Anshutz. In 1892 Anshutz went to Europe for a year, studying at the Academy Julian under Doucet and Bougereau. With Hugh Breckenridge he founded the Darby School of Painting at Fort Washington, Pennsylvania, and until his death in 1912 he continued to teach at the Pennsylvania Academy. His remarkable strength as a teacher was in recognizing an artist's inherent talent and encouraging it, no matter how different that form of expression was from his own. Among his many pupils were Robert Henri, William Glackens, George Luks, and John Sloan, all members of The Eight, and Stirling Calder, Arthur B. Carles, Charles Demuth, John Marin, and Charles Sheeler.

35 ANSHUTZ: Woman Drawing

Charcoal on paper; 24½ x 18¾ inches.
Unsigned; about 1895.

Despite Anshutz's emphasis on anatomy and the nude model, drawing from antique casts was still an integral part of the school curriculum. During these classes he would often sit among his students sketching the casts or drawing the students as they struggled for an accurate likeness of the Greek and Roman copies. In this drawing a woman student concentrates on a cast of the statue of a Greek river god (or hero?) from the west pediment of the Parthenon. This particular cast also appears in another Anshutz sketch, Cast Study with Students (Metropolitan Museum). His painterly use of charcoal and the finished quality of what was probably no more than an hour's work recalls Anshutz's statement that "it didn't make much matter what medium one used or what one chose to portray so long as one was learning how to paint."

EXHIBITED: James Graham & Sons, New York, 1963, *Thomas Anshutz,* no. 96, ill.; James Graham & Sons, 1964, *Six Early American Portraits,* no. 26; Gallery of Modern Art, New York, 1965, *Major 19th and 20th Century Watercolors and Drawings* (no catalogue).

EX COLL.: Son of the artist; [James Graham & Sons, 1963].

118

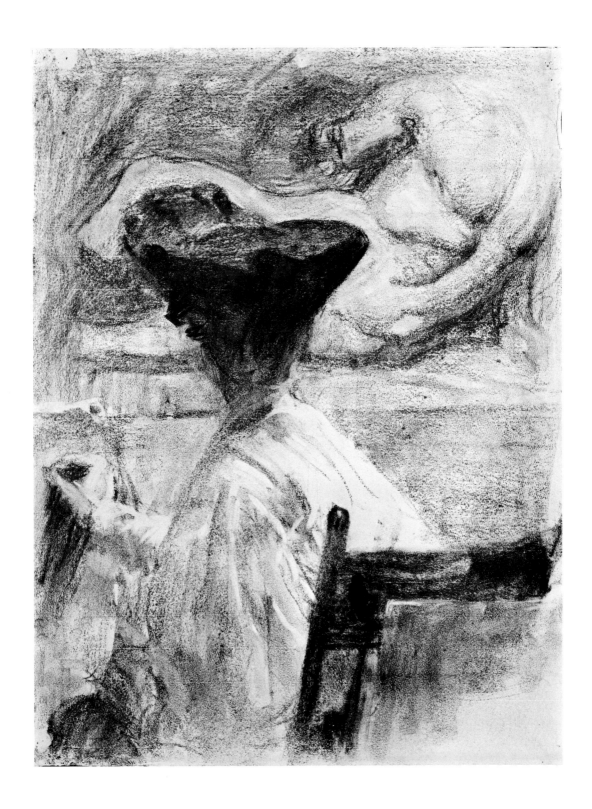

36 ANSHUTZ: Two Boys by a Boat

Watercolor on paper; 6 x 8½ inches.
Unsigned; about 1894.
Verso: watercolor sketch of a boy in a sailor suit.

Anshutz's frequent visits to the Maurice River, at the mouth of the Delaware in New Jersey, resulted in a series of watercolors of boys and boats. He often photographed the same subjects to compare what the camera recorded with his selective visual interpretation in paint. By the 1890s his palette had become lighter under the influence of impressionism. The geometrical composition and directness of this watercolor had already been seen in Aushutz's earlier masterpiece, Ironworkers: Noontime, about 1880–1882 (collection of Mr. and Mrs. Howard N. Garfinkle). The abstract and simple massing of forms in Two Boys by a Boat looked forward to the twentieth-century precisionists—Demuth and Sheeler, among others.

REFERENCE: Ruth Bowman, Telephone conversation with D.H.P., Sept. 1972.

EXHIBITED: James Graham & Sons, New York, 1963, *Thomas Anshutz* (not in catalogue).

EX COLL.: Estate of the artist; [James Graham & Sons, 1963].

120

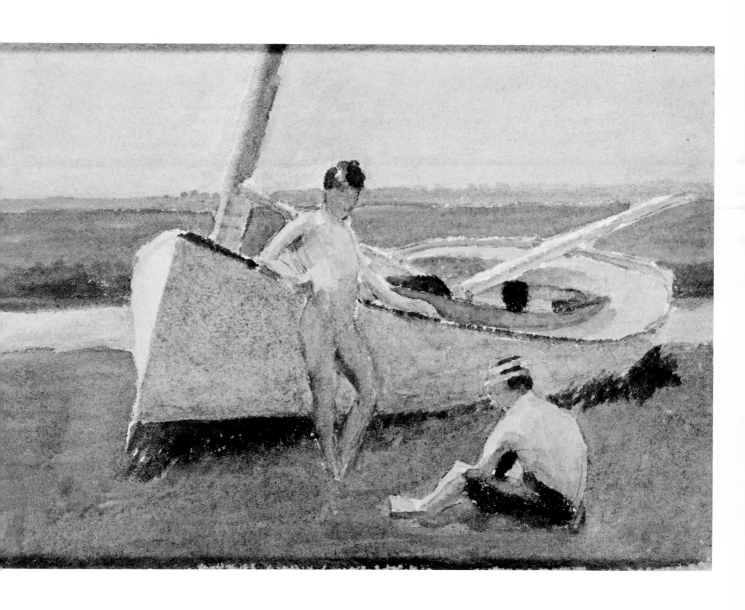

ROBERT HENRI

**1865-
1929**
About the turn of the century Henri—painter, teacher, and reformer—was the central figure in the progressive art movement in America. Without his persistent efforts at organizing progressive exhibitions, the atmosphere that produced the Armory Show in 1913 would not have existed. Henri was born Robert Henry Cozad in Cincinnati, Ohio. In 1882 Henri's father shot a man in self-defense, and the family all assumed different surnames in an attempt to end the scandal. Henri arrived at the Pennsylvania Academy in 1886 and studied under Anshutz. Even in his student days he displayed a talent for leadership, becoming the organizer of his fellow students. From 1888 until the fall of 1891 he studied in Paris at the Academy Julian. There he became interested in impressionism. When he returned to Philadelphia in 1891, he studied under Robert Vonnoh, an impressionist painter. In the fall of 1892 he himself started teaching—at the Philadelphia School of Design for Women. His studio became a gathering place for a group of young Philadelphians, including four future members of The Eight—Sloan, Glackens, Luks, and Shinn—who met there to discuss the arts, politics, and ethics. William Homer, Henri's most recent biographer and critic, describes Henri's feeling about the academic establishment: "Conservatism alone might have been excusable; when combined with absolute power over the fate of the young artist, it became intolerable." Henri settled in New York, quickly becoming the leader of the artistic rebels. He was invited in 1901 to organize a small exhibition for the Allan Gallery. This was the beginning of a series of progressive shows that culminated in the exhibitions of The Eight in 1908 and of the Independent Artists in 1910. Henri encouraged his students to avoid the sentimentality of many impressionist scenes; for the first time the urban and industrial landscape became the focus of the artist's attention, and when The Eight painted people, they were ordinary people in the midst of commonplace events. Soon after the Armory Show, Henri's leadership was eclipsed by younger and still more progressive artists whose painting looked toward European abstraction. Henri's dream of a native American art in his own time waned, but he continued to teach and his philosophy helped shape another generation: such men as Stuart Davis, Guy Pène du Bois, Rockwell Kent, Edward Hopper, Patrick Henry Bruce, Yasuo Kuniyoshi, Morgan Russell, and Andrew Dasburg.

37 HENRI: Girl Seated by the Sea

Oil on canvas; 18 x 24 inches.
Signed and dated (lower left): Robert Henri '93.

Like his compatriots, Henri could not identify with the more radical styles of the post-impressionists, whose work was being shown in Paris when he was first there (1888–1891). In fact, Henri attended the Academy Julian at the same time as the Nabis, but there is no indication that he had any association with them at that juncture. As late as 1892 in Philadelphia there was a furor over the impressionist paintings of Frank Benson, Edmund Tarbell, Henry McCarter, and Henri at the Pennsylvania Academy's annual show. Henri's work was placed next to Monet's paintings, which were considered incomprehensible. During the summers of 1892 and 1893 Henri executed a group of paintings at the New Jersey shore that represents his early impressionist phase. Girl Seated by the Sea was done in Avalon while he was teaching at the Avalon Summer Assembly. The theme of a woman posed on the beach in direct sunlight had intrigued Henri since his first European summer outing to Brittany in 1889. He successfully conveys the brilliance of the sun through the impressionist technique of brightly divided color, but he cannot dissolve the figure in light and color as Monet would have done. As William Homer has suggested, "Whatever its drawbacks might have been, his affiliation with Impressionism drew him to the contemporary world of everyday events as the source of his subject matter. And this mode demanded rapid and accurate perception of that world, along with the manual dexterity to convert these perceptions into a pictorial image. Thus Henri's rapid method of working and his belief in decisive, immediate brushwork may be traced, in part, to his Impressionist experience."

REFERENCES: William Innes Homer, *Robert Henri and His Circle*, Ithaca, New York, 1969, p. 213, pl. I; Norman Geske, Review of *Robert Henri and His Circle*, *Art Bulletin*, v. LIII, no. 4, Dec. 1971, pp. 549–550.

EXHIBITED: Main Street Gallery, Chicago, 1961, *American Painting 1740 to 1920*, no. 44, ill.; American Academy of Arts and Letters, New York, 1964, *Robert Henri (1865–1929) and His Circle*, no. 12; Sheldon Memorial Art Gallery, Lincoln, Nebraska, 1965, *Robert Henri, 1865–1929–1965*, no. 2, ill.; Metropolitan Museum, 1966, *Summer Loan Exhibition: Paintings, Drawings, and Sculpture from Private Collections*, no. 73; New York Cultural Center, 1969, *Robert Henri, Painter-Teacher-Prophet*, no. 4 (catalogue by Alfredo Valente).

EX COLL.: Estate of the artist; [Hirschl & Adler Galleries, New York, 1961].

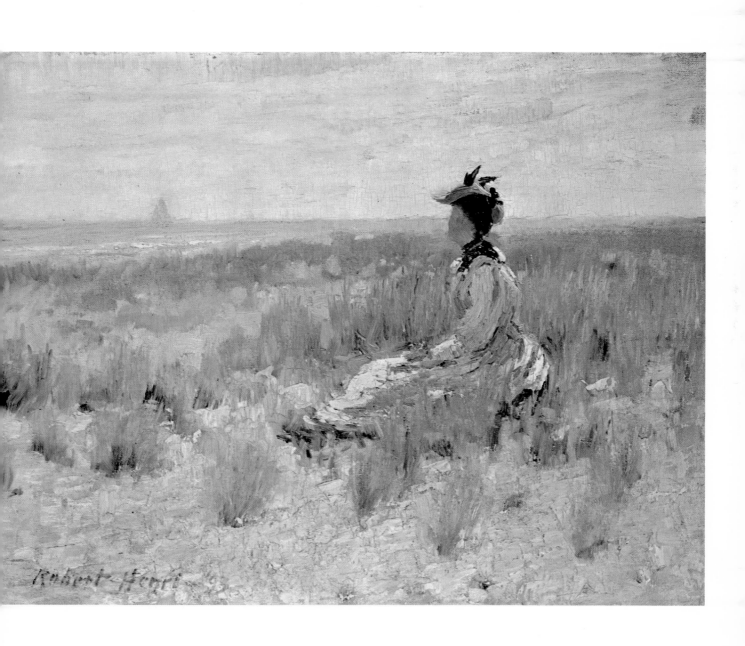

38 HENRI: Cafe Terrace

Oil on canvas; 32 x 25¾ inches.
Signed (lower right): Robert Henri; 1899.

In France during the second half of the 1890s, Henri developed his mature style. Under the influence of Frans Hals's paintings, the early work of Manet, Whistler, the Nabis, Velázquez, and Goya, his palette began to darken and rapid execution became his standard working procedure. His color scheme was restricted to ochers, greens, grays, and blacks, with a dab of white or a bright color for highlights. His change to tonal painting seems to have happened rather suddenly, although there had been a growing dissatisfaction among Henri's circle with impressionism. They felt that the style was too much involved with surface decoration and not enough with the direct and frank observation of the life around them. Henri is usually thought of as a portraitist, but in Paris in the late nineties he produced more than sixty cityscapes. These eloquent views of Parisian life demonstrate the many different influences on his work. Like Whistler, he became expert at suggesting mood, particularly at night. His application of paint recalls Manet's broad and free brushstroke. Like Prendergast, Henri was now influenced by Bonnard and Vuillard in the use of shallow space and a decorative approach to figures and architecture. The figures are generalized, their individuality sacrificed to create an overall pattern of color and tone. This scene is probably the Closerie des Lilas cafe, a favorite meeting spot for Glackens, Frank Du Mond, James Morrice, Henri, and the symbolist poets. There is a similar painting, probably of the same cafe, entitled Sidewalk Cafe (Museum of Fine Arts, Boston). When Henri returned to New York in 1900 he continued to do similar cityscapes, although gradually he abandoned these for his more popular figure and portrait paintings. Some of Henri's finest work was done in this early period when he was free from the demands of teaching and organizing exhibitions.

REFERENCE: *American Paintings in the Museum of Fine Arts, Boston*, 1969, v. 1, no. 544, p. 143, fig. 541.

EXHIBITED: Metropolitan Museum, 1931, *Robert Henri Memorial Exhibition*, no. 4, ill.; Whitney Museum of American Art, New York, 1937, *New York Realists, 1900–1914*, no. 21; Macbeth Gallery, New York, 1938, *"The Eight" (of 1908) Thirty Years After*, no. 8; Hirschl & Adler Galleries, New York, 1958, *Robert Henri, 1865–1929, Fifty Paintings*, no. 6; Hirschl & Adler Galleries, 1963/1964, *Selections from the Collection of Hirschl & Adler Galleries*, v. v, no. 28, ill.; M. Knoedler & Co., New York, 1965, *Lawyers Collect*, no. 25; Metropolitan Museum, 1966, *Summer Loan Exhibition: Paintings, Drawings, and Sculpture from Private Collections*, no. 74; New York Cultural Center, 1969, *Robert Henri, Painter-Teacher-Prophet*, no. 16 (catalogue by Alfredo Valente).

EX COLL.: Estate of the artist to Violet Organ estate; [Hirschl & Adler Galleries, 1963].

126

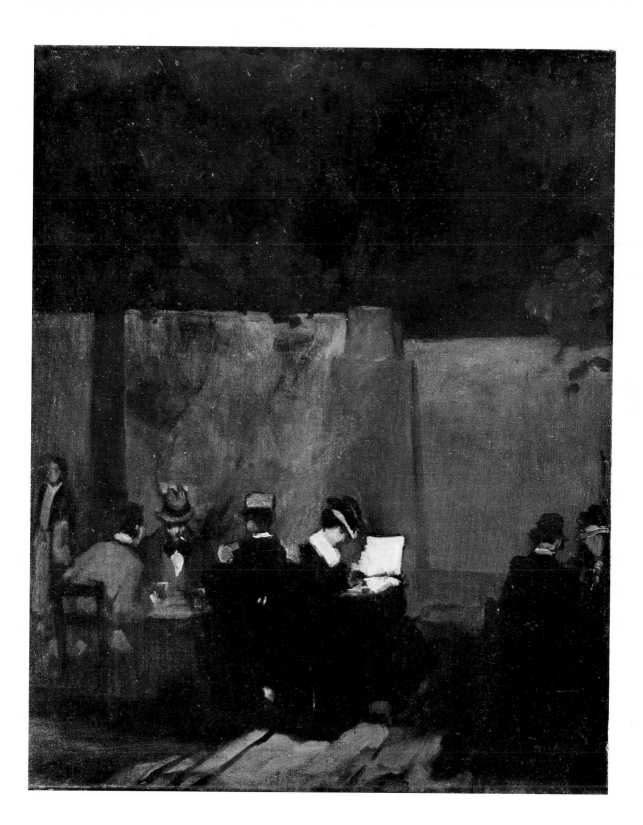

39 HENRI: Strollers' Rest

Pastel on paper; 12½ x 20 inches.
Signed (lower center): Robert Henri; 1918.

The Armory Show affected Henri's work in a number of ways. His use of color expanded to include a full palette, although this was due in part to his discovery of the Maratta system of color harmony in 1909. He began to conceive of color abstractly, but could never abandon subject matter for pure nonobjective painting. He came close in many of his later works, like this one, in which the figures and the background become almost indistinguishable from one another. His ever more rapid and summary brushstroke creates a work of vitality, which looks forward to the abstract expressionist painting of the 1940s and 50s. Strollers' Rest was painted on Monhegan Island off the coast of Maine. Visiting there in 1903, 1911, and 1918, Henri was thrilled by the elemental landscape. From his description one can more clearly imagine the setting where his wife, Marjorie, and sister-in-law, Violet Organ, are resting: "You can stand near the lighthouse and have a view of the ocean to the west and to the east—and from the great cliffs you look down on a mighty surf battering away at the rocks—or you can descend and get a side view of the cliffs from lower rocks and then you can disappear from the sea into the pine forests—they are wild. The village is on the inland side—a little harbor shielded by a small island—simply a huge mass of rock. It is a wonderful place to paint—so much in so small a place one could hardly believe it."

EXHIBITED: Pennsylvania Academy of the Fine Arts, Philadelphia, 1920, *18th Annual Philadelphia Water Color Exhibition*, no. 499; Montclair Art Museum, N.J., 1955, *Robert Henri*, no. 36; Hirschl & Adler Galleries, New York, 1958, *Robert Henri, 1865–1929—Fifty Paintings*, no. 37; Juster Gallery, New York, 1962, *American Water Colors and Drawings from 1900*, no. 29; New York Cultural Center, 1969, *Robert Henri, Painter-Teacher-Prophet*, no. 86 (catalogue by Alfredo Valente).

EX COLL.: Violet Organ; [Hirschl & Adler Galleries, 1962].

128

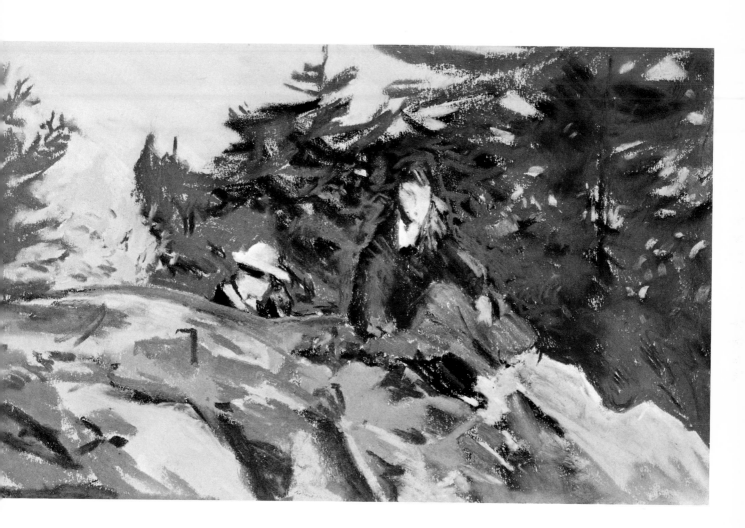

ALFRED HENRY MAURER

1868-1932 Maurer's early work is closely related to that of The Eight. The Manet-Whistler mode characteristic of Henri's painting during the late 1890s and early 1900s was skillfully developed by Maurer until a dramatic transformation in his attitude occurred sometime after 1904. By 1907 he had become a convinced modernist whose work revealed the influences of the fauves and cubists. His life was one of frustration and, in his mind, failure; his modern paintings were never well received. The last years of his life were marred by infirmity and bitterness. Maurer was born in New York, the son of Louis M. Maurer, a successful artist for Currier and Ives. At sixteen he was sent to work in the family lithography firm. Later he worked for A. Lenhard as a commercial artist. In his spare time he attended classes at the National Academy of Design. At the age of twenty-nine, determined to become a painter, Maurer broke away from his family and went to Paris. He attended the Academy Julian for only a week or so, preferring to work alone. He became friendly with Henri, who was in Paris at this time. Upon his return to America in 1901, he painted An Arrangement (Whitney Museum of American Art), an elegant work much influenced by Whistler. This painting won the Carnegie Institute's gold medal, and considerable fame followed for the newly established artist. While in New York that year he also participated in the show organized by Henri at the Allan Gallery. The other participants were Glackens, Ernest Fuhr, Henri, Van Dearing Perrine, Sloan, and Willard Bertram Price. It was at this time that Maurer and Glackens became close friends. He returned to Paris in May 1902 with renewed confidence. Soon after Gertrude Stein and her brother, Leo, arrived in 1904, Maurer made their acquaintance. It was then that he rejected his aesthetic past and adopted modern art. Certainly rebellion was in the air, but why he gave up the security of his previous success is not known. After a period of reflection, during which he did not paint, he began to execute work in his new style about 1907. In 1909 Maurer exhibited at Alfred Stieglitz's Photo-Secession Gallery, "291," in New York and in the Armory Show in 1913. After this, long years of critical rejection finally led him to suicide.

40 MAURER: At the Shore

Oil on cardboard; 23½ x 19¼ inches.
Unsigned; 1901.

When Maurer first went to Paris, Whistler was the dominant influence on his work, especially in terms of color and tone. The dark colors of Hals and early Manet and the subtle tonal qualities of Whistler captured the imagination of a number of Americans. At the Shore, painted while Maurer was in New York in 1901, and one of his few American scenes, shows him intrigued, like Whistler, by the delicacy of tone and value possible in the manipulation of white. The painting at first glance appears to be almost monochromatic. Yet, by his subtle use of closely related values and with only brief accents of bright color, he has infused the scene with the luminosity of a bright summer day. Although Maurer never adopted the rainbow palette and technique of the impressionists, he shared one of their favorite themes—a candid view of the leisure class. His figures here are indicated in broad strokes, with no attempt to individualize their features. The mood is festive, capturing the curiosity of the crowd as they watch a performing monkey.

REFERENCES: Elizabeth McCausland, *A. H. Maurer*, Minneapolis, 1949, p. 31; Elizabeth McCausland, *A. H. Maurer*, New York, 1951, pp. 69–70, ill. p. 57; Milton W. Brown, *American Painting from the Armory Show to the Depression*, Princeton, N.J., 1955, ill. p. 32.

EXHIBITED: Walker Art Center, Minneapolis, 1949, *A. H. Maurer*, 1868–1932, no. 4 (traveled to Whitney Museum of American Art, New York, Boston Institute of Modern Art); Whitney Museum of American Art, 1964, *The Friends Collect*, no. 104; Metropolitan Museum, 1966, *Summer Loan Exhibition: Paintings, Drawings, and Sculpture from Private Collections*, no. 97; Metropolitan Museum, 1967, *Summer Loan Exhibition: Paintings from Private Collections*, no. 59.

EX COLL.: Hudson D. Walker to Curt Valentin to Curt Valentin estate; Richard Sisson; [Babcock Galleries, New York, 1963].

132

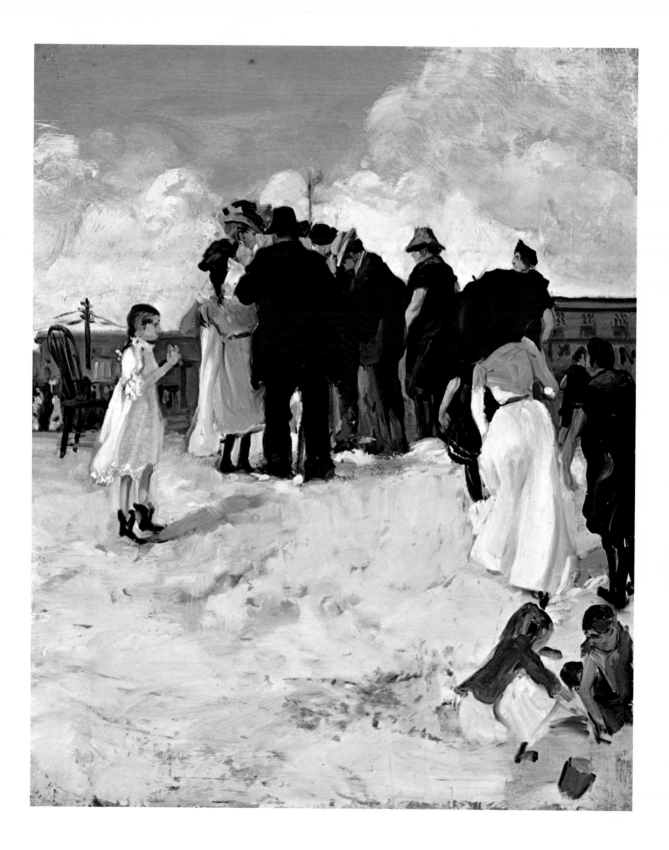

41 MAURER: Cafe Scene

Oil on canvas; 36 x 34 inches.
Signed (lower right): Alfred H. Maurer; about 1904.

When Maurer returned to Paris in 1902, he began to chronicle the world of the cafes, circuses, and clubs. Despite the sadness of his life, he was quite a dandy, who loved dancing, drinking, women, and parties. For two years he worked hard and productively, gaining in technical assuredness. Although similarities exist between this cafe scene and the one by Henri, Maurer invests his with a more lively and poignant mood. He was not a social critic, as Lautrec was, but he communicates the underlying pathos in the tawdry life of the dancing women. "When Maurer painted the girls in cafes," his biographer, Elizabeth McCausland, writes, "sitting at tables, dancing with Zouaves or with each other, standing in twos and threes conversing, he did so with tenderness for the worldly airs they affected, but also with understanding for the fatigue and ennui in the lines about their eyes and mouths, with a gallant nod toward the pathetic finery in which they displayed their charms." Like Henri, Maurer seems to have been aware of the work of the Nabis, as he uses almost flat space, which is divided by horizontals and verticals, rather than depth, which is created by diagonals. His figures are flattened to make patterns and movement. The vitality of the scene suggests the influence of Bonnard or Vuillard more than Henri. Maurer must have been pleased with this painting, as he affixed his signature to it. According to McCausland, he signed few paintings and rarely dated them. During recent restoration, two inches on the right side were discovered folded under the stretcher. Since it is not known who decided to alter the canvas, the painting has been restored to its full dimensions.

REFERENCE: Elizabeth McCausland, *A. H. Maurer,* New York, 1951, pp. 77–78.

EXHIBITED: Walker Art Center, Minneapolis, 1949, *A. H. Maurer, 1868–1932,* no. 11 (traveled to Whitney Museum of American Art, New York, Boston Institute of Modern Art).

EX COLL.: Ione and Hudson Walker Collection, University of Minnesota, Minneapolis; [Babcock Galleries, New York, 1968].

EVERETT SHINN

**1876-
1953**

The most versatile of The Eight, Shinn was an illustrator, painter, muralist, interior and stage designer, and playwright. His association with the realist group began in Philadelphia when he was a busy newspaper artist-reporter. Born in Woodstown, New Jersey, he went to Philadelphia at fifteen to study mechanical drawing at the Spring Garden Institute; his talents and interests at that point were scientific rather than artistic, and after two years of training he took a job with Thackeray's Gas Fixtures Works. He soon became bored with the inflexibility of his job and was encouraged by the foreman to attend art school. In 1893 Shinn entered the Pennsylvania Academy of the Fine Arts and at the same time found a job with the *Philadelphia Press*. Shortly thereafter another young man, George Luks, joined the staff, and they became roommates. By the fall of 1894 they were attending Henri's weekly meetings. Soon Sloan, Glackens, Luks, and Shinn were all good friends, although they never worked together for the same newspaper. In 1897 Shinn moved to New York, joining Glackens and Luks on the staff of the *New York World*. By 1900 he had abandoned newspaper work for the more lucrative field of magazine illustration. Somewhere between 1900 and 1903 he spent almost a year in Paris. By then the theater had become a major preoccupation, and, in turn, Degas became his main source of artistic inspiration. He wrote more than thirty-five plays and painted portraits of most of the great theatrical personalities of the time. He decorated the Belasco Theater and the home of Clyde Fitch in a style that recalled eighteenth-century French rococo. His diversity of interests soon alienated Shinn from the rest of The Eight, but his early protest against the National Academy and the vitality of his New York and Paris vignettes contributed to the progressive artistic atmosphere.

42 SHINN: Matinee, Outdoor Stage, Paris

Pastel on paper; 18 x 26 inches.
Signed and dated (lower right): E. Shinn/1902.

Shinn was a master of pastel. The medium suited his quick and sure draughtsmanship, and with it he portrayed the life of New York and Paris. Like the Philadelphia realists, he did street scenes, but most of his work portrays the excitement and make-believe world of the theater and circus. Degas was not the only influence on his work; Daumier, Lautrec, and even Renoir can be seen, particularly in this pastel of an outdoor stage. Although he does not usually convey the same cynicism or poignancy found in the work of Degas and Lautrec, the spectacle, the conviviality, and, at times, the artificiality of the entertainment world are vividly transmitted. His characters are generalized as types, and his distribution of highlights creates a pattern, further heightening the dramatic effect. Shinn's talent was for grasping the essence of a scene rapidly, with skill and sensitivity.

EXHIBITED: James Vigeveno Galleries, Los Angeles, 1945, *Paintings by Everett Shinn of Paris and New York, 1902–1945,* no. 1 (as Matinee, Music Hall, Paris, 1902); Philadelphia Museum of Art, 1945, *Artists of the Philadelphia Press,* no. 36, ill. p. 6 (as Matinee, Paris Music Hall, 1902); James Vigeveno Galleries, 1947, *Circus and Theatre by Everett Shinn,* no. 10.

EX COLL.: Artist to Mr. Lindeberg to Barbara Lindeberg; Hanover Arts Associates; Stanley Moss, Ltd.; [Schoelkopf Gallery, New York, 1972].

WILLIAM GLACKENS

1870-1938 While he was working as a newspaper illustrator in Philadelphia, Glackens received encouragement from Robert Henri and determined to become an artist. Born and raised in Philadelphia, he attended Central High School along with John Sloan and the collector Albert C. Barnes. After graduation in 1888 he went to work as an artist-reporter, first for the *Philadelphia Record,* then the *Press* and the *Public Ledger.* He enrolled as a part-time student at the Pennsylvania Academy of the Fine Arts from 1892 until 1894 and worked under Henry Thouron and briefly with Thomas Anshutz. In 1894 Glackens and Henri became close friends, sharing a studio on Chestnut Street. Along with Henri and four other Philadelphia artists, Glackens set off for Europe in 1895. After bicycling through Belgium and Holland, the men went on to Paris. Here Glackens worked closely with Henri and James Wilson Morrice, painting Parisian cityscapes and scenes of the countryside around Fontainebleau. Under the direct influence of Henri and indirectly from the work of Whistler and Manet, Glackens developed a style using the dark palette typical of the realist group at the turn of the century. In 1896 he settled in New York, working for the *New York Herald,* the *World* and for magazines. He first exhibited at the Allan Gallery in 1901, the group show organized by Henri. Three years later at the National Arts Club, Henri organized another independent exhibition of forty-five paintings by himself, Davies, Glackens, Luks, and Prendergast. So the groundwork was laid for the 1908 exhibition of The Eight, in which Glackens was to take part. He did not dramatize his stance against the Academy, but continued to participate quietly in the organization of the exhibition of Independent Artists and the Armory Show of 1913. He went to Europe in 1912 to purchase paintings for Albert C. Barnes, returning with works by Manet, Degas, Renoir, Cézanne, Van Gogh, Gauguin, and Matisse. Around 1914 he gave up illustration to devote his full time to painting.

43 GLACKENS: Seated Woman

Ink wash, charcoal on paper, heightened with pastel; 18⅝ x 14¾ inches.
Signed (lower right): Glackens; inscribed (back of paper): Drawn by W.
J. Glackens/size 11½ x 15½/date—possibly 1887/Price $. . ./Possibly
drawn from a model in the sketch class at the Philadelphia Academy of
Fine Arts/Given to E. Shinn later. Not signed but authentic/the above
attested by/Everett Shinn; about 1902.

A born draughtsman, Glackens was ideally suited to his job as an artist-reporter.
He was gifted with an extraordinary visual memory. It is said that he could go out
on an assignment without pencil and paper and still produce an accurate drawing
when he returned to his office. Shinn said, "Newspaper work compelled [artists]
to observe, select and get the job done." Both Glackens and Shinn developed into
superb draughtsmen as a result of having to make quick, accurate sketches. This
drawing of a woman leaning back is wonderfully free and spontaneous, yet it faith-
fully records the essentials of her physiognomy. For all its sketchiness and vivacity
of line there is great solidity and naturalness to the figure. A reporter in 1899 con-
cluded: "As a draughtsman of force and original and unique methods of presenting
ideas, Mr. Glackens is assuredly making a place for himself, and one that no other
American illustrator has heretofore occupied."

REFERENCE: Ira Moscowitz, ed., *Great Drawings of All Time*, New York, 1962, v. IV, no.
1020, ill.

EXHIBITED: Currier Gallery of Art, Manchester, N.H., 1962, *100 American Drawings from
the Collection of Paul Magriel*, no. 41, ill.; American Academy of Arts and Letters, New York,
1964, *Robert Henri (1865–1929) and His Circle*, no. 94; City Art Museum of St. Louis, 1966,
William Glackens in Retrospect, no. 96, ill. (traveled to National Collection of Fine Arts,
Washington, D.C., Whitney Museum of American Art, New York); Metropolitan Museum,
1968, *New York Collects: Paintings, Watercolors, and Sculpture from Private Collections*,
no. 66.

EX COLL.: Artist to Everett Shinn; Joseph Katz, 1959, to Babcock Galleries, New York; Paul
Magriel; [Kennedy Galleries, New York, 1968].

44 GLACKENS: The Ermine Muff

Oil on canvas; 15 x 18 inches.
Unsigned; about 1903.

Although Glackens's early work was similar in style and color to Henri's, at heart he was always an impressionist. A certain optimism pervades his paintings, in which people take pleasure in everyday events. Guy Pène du Bois, artist and critic, characterized the mood as "the picnic spirit." The trip to Europe with Henri in 1895 had set the tone for his earlier style. Reacting against what they considered the unnatural color of the impressionists, Glackens and Henri quickly absorbed the style of Hals, Manet, and Whistler. In the early 1900s they were doing very similar cityscapes. In this interior scene the color is almost monochromatic, the only highlights being the muff and scarf. Yet the influence of impressionism can be seen in the arbitrary placement of pictorial elements in relation to the picture plane, the diagonal upsweep of the floor and sofa, the casualness of the sitter, and the informality of the scene. The brushstrokes are broad and loose, with more emphasis on painting than on detail. It is not surprising that as Glackens gained confidence in himself as an artist, his color and technique became more impressionistic. By 1910 he was to fall completely under the influence of Renoir's brighter color and feathery brushwork.

EXHIBITED: 10 West Ninth Street, New York, 1942, *4th Annual Memorial Exhibition of the Paintings of William Glackens*, no. 4; City Art Museum of St. Louis, 1966, *William Glackens in Retrospect*, no. 10, ill. (traveled to National Collection of Fine Arts, Washington, D.C., Whitney Museum of American Art, New York); Metropolitan Museum, 1968, *New York Collects: Paintings, Watercolors, and Sculpture from Private Collections*, no. 67.

EX COLL.: Mr. and Mrs. Ira Glackens; [Kraushaar Galleries, New York, 1967].

144

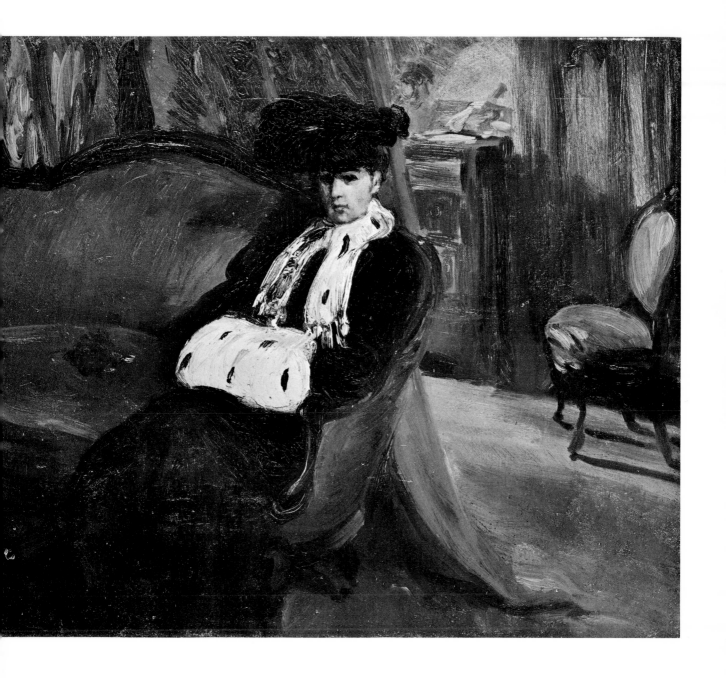

45 GLACKENS: Study of a Young Man
(Portrait of Everett Shinn)

Red chalk on paper; 10 x 8⅛ inches.
Signed (lower right): W Glackens; about 1903.

Good friends during their Philadelphia newspaper days, Glackens and Shinn remained close after they moved to New York. This relaxed and personal portrait must have been done when Shinn was in his middle twenties. He had a very boyish face, looking much younger than he actually was. One can almost imagine Glackens drawing his friend in the room where he painted The Ermine Muff. Shinn seems to be seated on the same chair that appears in the right side of the other painting.

EXHIBITED: City Art Museum of St. Louis, 1966, *William Glackens in Retrospect,* no. 101, ill. (traveled to National Collection of Fine Arts, Washington, D.C., Whitney Museum of American Art, New York).

EX COLL.: Mr. and Mrs. Ira Glackens; [Kraushaar Galleries, New York, 1967].

146

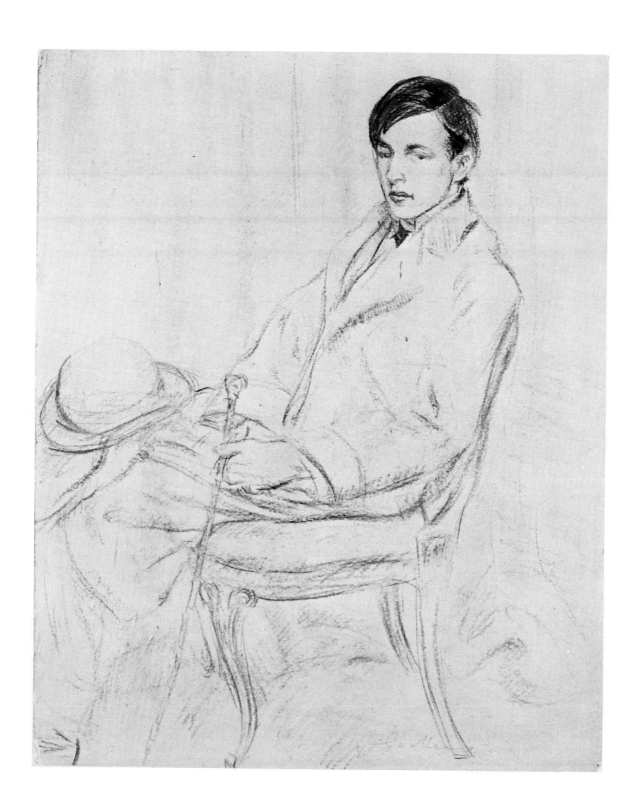

JOHN SLOAN

**1871-
1951**

Sloan recorded more faithfully than any other member of The Eight the spirit and character of New York City. He loved to walk the streets, observing people and places. He was an incurable window watcher, delighting in the close-up view of everyday scenes. Sloan was born in Lock Haven, Pennsylvania. Along with Glackens and Albert C. Barnes, he attended Central High School in Philadelphia until 1887, when he became an assistant cashier at Porter and Coates, a leading dealer in books and prints. From 1890 until 1892 he worked as a commercial artist. He then started his first newspaper job with the *Philadelphia Inquirer* and entered a cast-drawing class at the Pennsylvania Academy of the Fine Arts under Thomas Anshutz. It was then he first met Robert Henri. Henri's magnetism and love for art and life gradually decided Sloan on a career as an artist. He continued his newspaper work, though, until 1903, and after his move to New York in 1904 his chief source of income was from illustrations for magazines. Sloan participated in the Allan Gallery exhibition of 1901, the 1904 National Arts Club Show, the exhibition of The Eight in 1908, the exhibition of the Independent Artists in 1910, and the Armory Show of 1913. Although he was the most politically oriented of The Eight and was a member of the Socialist Party for four years, he never used his art as a political tool. Sloan, unlike Henri, would admit to being greatly influenced by the Armory Show. "I consciously began to be aware of the technique of art: the use of graphic devices to represent plastic forms. While I have made no abstract pictures, I have absorbed a great deal from the work of the ultra-moderns." Van Gogh and Renoir were the two moderns he most admired. As a result, his color became clearer and more brilliant. His New York views became more impressionistic. His people were not individualized, but usually presented in groups, and light, whether daylight or electric, became an important feature of his work; he now dramatized the mood of the city rather than its inhabitants. Around 1928 he became interested in the sculptural possibilities in the human figure. His paintings began to look like his etchings, with crosshatchings over the entire forms. As was the case with many of his contemporaries, his work was considered too radical in the beginning to sell well and too conservative later to be popular.

46 SLOAN: The Savings Bank
(The Greenwich Savings Bank)

Oil on canvas; 32 x 26 inches.
Signed (upper right): John Sloan; inscribed (back of canvas):
Savings Bank; 1911.

Sloan first began to paint seriously in oil in 1897 under the guidance of Henri. Though his friend encouraged him to go to Europe, Sloan never did go abroad. Henri was his main source of knowledge, instilling in him a love for the work of Velázquez, Hals, Rembrandt, Goya, Manet, and Whistler. Sloan began by making portrait heads similar in style and character to Henri's; and a year later he was painting Philadelphia city scenes. The move to New York in 1904 to join his friends was the turning point in his life. Sloan had a love affair with the city. An insatiable observer of people, he caught the vitality and aura of a cross-section of city dwellers: their amusements, their foibles, their daily existence. He reported these things with affection, and only sometimes with satire. Though he did not always paint the genteel side of life, his point of view almost always reflected the late-nineteenth-century optimism that persisted until World War I. Almost all his work was painted from memory. His approach was an intuitive working-out directly on the canvas in broad and spontaneous brushstrokes. The dark tonality of these paintings reflects Henri's influence and the reaction against the "sweet" colors of the impressionists. In 1906 Sloan started a diary. The idea for this painting and its development can be followed in it: "At the Greenwich Savings Bank today I was hit by the idea that it would make a good subject for picture—and, indeed, I have thought it before. A great number there, and each an interesting life.... The vast buff and gold interior of the bank, the glass-hooded gratings about the counters where the clerks under electric lights handle the book and money" (20 January 1908). "Went to the Savings Bank.... Good thing to paint.... I've had the idea before...started on Savings Bank interior. Drew with charcoal the figures and planned the composition. Looks good to me" (10 November 1911). "Put away $5.00 as an excuse to enter the sacred home where the poor thrifty should stand and sit in awe of the columns and gold and glass which their own money [built]. Back then, and after setting the palette (which is no quick job with the present scheme of color arrangement—Oh great Maratta!) I got to work on the picture" (11 November 1911). Years later, in his *Gist of Art,* he

wrote, "The odor of the sanctity of money was my literary motive behind the painting of this interior of the Greenwich Savings Bank on lower Sixth Avenue. I like the picture and feel that the preaching is not too obvious. What was the first cause has become of little importance in the result."

REFERENCES: *The Sun*, New York, 27 Oct. 1912; *New York Herald*, 26 Jan. 1916; *New York Evening Post*, 29 Jan. 1916; *The Sun*, 30 Jan. 1916; *New York World*, 30 Jan. 1916; *New York Globe*, 31, Jan. 1916; *New York American*, 8 Feb. 1925; *New York Times*, 4 Jan. 1934, p. 17; John Sloan, *Gist of Art*, New York, 1939, p. 228, ill.; *Santa Fe New Mexican*, 8 Aug. 1942; Lloyd Goodrich, *John Sloan*, New York, 1952, p. 37, ill.; Van Wyck Brooks, *John Sloan, A Painter's Life*, New York, 1955, pp. 67–68; Bruce St. John, ed., *John Sloan's New York Scene: From the Diaries, Notes and Correspondence, 1906–1913*, New York, 1965, pp. 186, 577–579; *American Heritage*, New York, 1968, p. 72, ill. p. 73; John Sloan, "Diary" (unpublished); Grant Holcomb, Letter to D. H. P., 14 March 1972.

EXHIBITED: Folsom Gallery, New York, 1912; Pennsylvania Academy of the Fine Arts, Philadelphia, 1914, *109th Annual Exhibition*, no. 228; Whitney Studio, New York, 1916, *Exhibition of Paintings, Etchings, and Drawings by John Sloan*, no. 18; Hudson Guild, New York, 1916, *John Sloan Exhibition of Paintings*, no. 39; Kraushaar Galleries, New York, 1925, *Exhibition of Paintings by John Sloan*, no. 8; Montross Galleries, New York, 1934, *John Sloan*, no. 11; Museum of New Mexico, Santa Fe, 1942; Whitney Museum of American Art, New York, 1952, *John Sloan, 1871–1951*, no. 27 ill. p. 37; Cincinnati Art Museum, 1958, *Two Centuries of American Painting*, no. 40.

EX COLL.: Kraushaar Galleries; Dr. and Mrs. Irving Levitt; [Kennedy Galleries, New York, 1971].

JOSEPH STELLA

1877-1946

Stella was America's first and leading futurist painter, an artist who glorified the excitement and vitality of New York City. Less known is his remarkable ability as a draughtsman. He was born in Muro Lucano, Italy, and in 1896 followed his older brother to the United States. His brother, a doctor, encouraged Stella to study medicine and pharmacology, but after a year or so of that he enrolled at the Art Students League. He was there only a short time before he attended the New York School of Art. Stella also painted at William Merritt Chase's summer school at Shinnecock Hills. There Chase was quite taken by one of Stella's portrait studies, telling the class, "Manet couldn't have done it any better." Stella's early style reflects Chase's bravura brushwork and the dark tonalities of Rembrandt, Hals, and Velázquez. On the Lower East Side, where he lived, he began to sketch, trying "to catch life flowing unawares with its spontaneous eloquent aspects, not stiffened or deadened by the pose." The democratic spirit at the turn of the century affected Stella as well as Henri and his group. The Eight were all from the middle class and viewed the common man from a distance. Stella's approach to his surroundings and his fellow immigrants was naturally far more immediate and emotional. His first published drawings appeared in the *Outlook* in 1905. Entitled "Americans in the Rough," they depicted immigrants at Ellis Island. The magazine *Survey* sent him to West Virginia in 1907 to do drawings of the Monongah mine disaster and in 1908 commissioned him to do a large series of drawings of the Pittsburgh industrial scene. He produced over one hundred drawings of Pittsburgh and formed a concept of this country which was to become a dominant factor in his work. Irma Jaffe writes in her book on Stella: "The romance and stark realism fused in the spectacle of coal being mined and steel manufactured became a major force in shaping his responses to American life.... The modern world, the United States, steel, and electricity were forged into a single concept then and forever in his imagination." In 1909 or 1910 he returned to Italy for a year or so, but it was not until he went to Paris in 1911/ 12 that he discovered the Italian futurists and proceeded to immerse himself in all the modern developments. Freed from the past, he returned to America late in 1912. For the next decade, beginning with Battle of the Lights, Coney Island, 1913 (Société Anonyme, Yale University), Stella paid homage to modern New York. As he said, "New York is my wife."

153

47 STELLA: Back of a Woman, Sleeping

Pencil on paper; 5½ x 8¼ inches.
Signed (lower right): Joseph Stella; about 1910.

According to his own notes, Stella as a schoolboy "began to draw everything of interest, and was always busy in making likenesses of his classmates." From 1900 until 1912 he did hundreds of drawings, many of which show the influences of the old masters. "The forceful penetrating characterization of Mantegna's engravings," he wrote, "and the powerful dramas depicted for eternity by Giotto and Masaccio, so much admired in the mother country, were ever present in front of me, urging me to search for tragic scenes." Unlike that of Luks, Glackens, Shinn, and Sloan, Stella's approach was never journalistic, but conveyed his emotional response to his subjects. It is extremely difficult to date Stella's work, since he often worked in several styles simultaneously. This drawing was probably done after he returned to Italy in 1909. Stella's debt to the classical aspects of Renaissance art is obvious in the flowing lines and generalized modeling of the figures. The meticulous realism of his immigrant studies has disappeared. "Particularly interesting," says Irma Jaffe, "is the emergence at this time of a tendency to create shapes which, while justified as shadows within the representational context of the drawing, assert themselves as independent, abstract forms. These strange shadows...become particularly striking in drawings, not of the Pittsburgh series but apparently slightly later, of which ... the Back of a Woman, Sleeping [is one example]."

REFERENCES: *Drawings of Joseph Stella from the Collection of Rabin & Krueger,* Newark, N.J., 1962, no. 31, ill.; John I. H. Baur, *Joseph Stella,* New York, 1971, no. 23; Irma B. Jaffe, *Joseph Stella,* Cambridge, Mass., 1970, pp. 22–23, ill. pl. 23.

EXHIBITED: Whitney Museum of American Art, New York, 1963, *Joseph Stella Exhibition,* no. 75, ill. p. 18.

EX COLL.: [Rabin & Krueger Gallery, 1962].

CHARLES WEBSTER HAWTHORNE

**1872-
1930**

Hawthorne continued the painterly and realistic tradition of William Merritt Chase well into the twentieth century. Although he developed his own style, he told his numerous students, much as Chase might have, that "anything under the sun is beautiful if you have the vision—it is the seeing of the thing that makes it so." These words were spoken at a time when the academic tradition was being severely threatened, not only by The Eight but by the abstractionists after the revolutionary Armory Show of 1913. For Hawthorne, steeped in the traditions of the generation before him, it was natural to continue painting ordinary people, his family and neighbors. Hawthorne was born in Lodi, Illinois, but grew up in Richmond, Maine, where his father was a sea captain. In 1890 he arrived in New York determined to become a painter. He held menial daytime jobs while attending the Art Students League at night. He entered Frank Du Mond's evening classes in 1893 and in 1894/95 he worked with George de Forest Brush and Siddons Mowbray at the League. During the summer of 1896 Hawthorne studied with William Merritt Chase at Shinnecock Hills, Long Island. That fall he helped Chase organize his New York school and the following summer became his assistant at Shinnecock. The summer of 1898 found Hawthorne in Holland enraptured by the work of Frans Hals. Both this trip and another to Italy in 1906 had a tremendous effect on his work. The monumentality, the mystery, the deep tonalities and the sheer joy of painting that permeate the work of artists like Titian and Tintoretto deeply influenced his approach. Edgar Richardson points out that Hawthorne's "admiration for the sixteenth-century Venetians links him with a vein of feeling in American painting which began with Allston and included Page, Fuller [and] Arthur Davies." In 1899 Hawthorne founded the Cape Cod School of Art in Provincetown, Massachusetts. The light, the sea, and the natural beauty of the place attracted him at first, but quickly it became the people who fascinated him the most. The Yankee and Portuguese fishermen became his favorite subjects in numerous paintings throughout the rest of his life. The school was an enormous success up until the very time of Hawthorne's death.

48 HAWTHORNE: April

Oil on canvas; 39¾ x 39¾ inches.
Signed (lower right): C W Hawthorne; 1920.

It is the mood of his sitters, their introspection, that separates Hawthorne's work from that of many of his academic contemporaries. His figures were sometimes criticized for seeming too sad. Hawthorne responded: "I realize that your criticism of their being 'sad' is just, but I am not going to try to please the newspapers—they are a flock of sheep who have gone crazy on the new art idea. They are calling me 'old hat' because I don't swing with every new fad. They don't seem to realize that it takes a man about a life time to do one thing." This portrait of Margaret Wilson, Hawthorne's secretary from 1920 until his death, is a good illustration of the artist's fascination with white, and the problems of color and luminosity it presented. The painter Edwin Dickinson, a close friend, explained Hawthorne's interest in white: "It is because the human eye distinguishes most clearly and easily at the top of the palette, as between lemon yellow and yellow ochre, for example. At the bottom of the palette the eye distinguishes slowly. It is the same in music. In tuning the E string of the violin the least change is quickly seen. The A string tunes more slowly." Hawthorne did at least three other individual portraits of Miss Wilson and included her in a number of his Madonna and adoration scenes. There is another, smaller painting also entitled April, but its date, sitter, and present whereabouts are unknown. The theme of womanhood, which had been so popular in the late nineteenth century, was continued by Hawthorne, but his treatment was different. This figure stands directly before the viewer, unidealized, lost in reverie. A mysterious effect is created by the use of a two-dimensional landscape backdrop, which depicts a magical and imaginary world.

REFERENCE: "Treasures from the University Museum of Art, a Portfolio," *Connecticut Alumnus*, v. XLIII, no. 2, Dec. 1968, p. 5, ill.

EXHIBITED: Art Institute of Chicago, 1921, *34th Annual Exhibition of American Painting and Sculpture*, no. 188; Macbeth Gallery, New York, 1922, *Recent Paintings: Portrait and Figure Compositions by Charles W. Hawthorne, N.A.*, no. 2; *Seconda Biennale Romana Mostra Internazionale di Belle Arti*, Rome, 1923, no. 18, p. 183; Art Institute of Chicago, 1927 (one-man exhibition); Carnegie Institute of Pittsburgh, 1928 (one-man exhibition); Currier Gallery of Art, Manchester, N.H., 1930; Century Association, New York, 1931; American Academy of Arts and Letters, New York, 1939; Chrysler Art Museum of Provincetown, Mass., 1961, *Hawthorne Retrospective*, no. 88, ill.; Davenport Municipal Art Gallery, Iowa, 1963, *American Sampler;* Metropolitan Museum, 1967, *Summer Loan Exhibition: Paintings from Private Collections*, no. 47; University of Connecticut Museum of Art, Storrs, 1968, *The Paintings of Charles Hawthorne*, no. 29, ill. (traveled to Hirschl & Adler Galleries, New York).

EX COLL.: Estate of the artist; [Babcock Galleries, New York, 1966].

158

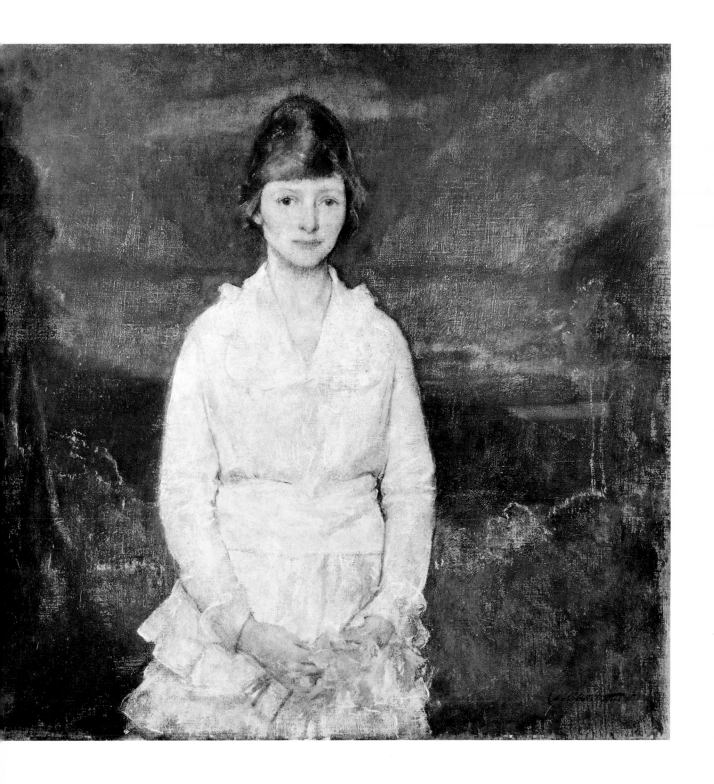

GEORGE WESLEY BELLOWS

**1882-
1925**

Robert Henri's prize pupil and intimate friend, Bellows was a decade younger than most of the artists of The Eight, with whom he became closely connected. He was born in Columbus, Ohio. A good athlete, he nevertheless became convinced that he belonged in art school, and he left Ohio State University after his junior year. In 1904 he enrolled at the New York School of Art, where he became an ardent disciple of Henri. By 1906 he had his own studio. To help make ends meet, he at first played professional baseball. However, success came quickly for Bellows. He was accepted in the 1907 National Academy of Design exhibition, the next year he received the Hallgarten second prize, and in 1909 he was elected an associate of the Academy, the youngest member ever so honored. Four years later he was made a full academician. Despite his academic status, he rallied to the defense of his struggling artist friends. He participated in both the exhibition of the Independent Artists in 1910 and in the Armory Show, 1913. Bellows's masculine vitality and optimism, which permeated his painting as well as his life, was most attractive to the American public; at a time when most of The Eight were still hoping for acceptance, Bellows was enjoying considerable popularity with his street scenes and urchins, landscapes and portraits. His vigorous depictions of boxing matches were enormously popular. Bellows never went to Europe. Even more than John Sloan, he became recognized as *the* American artist.

49 BELLOWS: Swans in Central Park

Oil on canvas; 18¾ x 21⅜ inches.
Signed (lower right): Geo. Bellows; 1906

In New York in the fall of 1905 Bellows began to attend Henri's "Tuesday evenings,"
where he met the rest of The Eight. That winter he concentrated on portraits of his
friends, painting only one street scene. Early in 1906 he completed his first major
painting, Kids (collection of Mr. and Mrs. Daniel Fraad), which was shown in the
final exhibition of the Society of American Artists in March 1906. During the sum-
mer, while the New York School of Art was closed, Bellows settled down to the work
of becoming a painter. His first painting that June was Swans in Central Park.
Henri's influence is evident in the thick, energetic brushwork and the dark, almost
monochromatic color scheme. However, in a curious way, the painting seems closer
to the early work of Glackens than of Henri. Bellows and Glackens share a penchant
for silhouetting figures and trees in the foreground against a lighter background. In
this case the water covers three-quarters of the canvas. Both painters drew their
figures and strange, stalky trees very quickly and cursorily. Their subjects are all
somewhat anecdotal, children feeding swans, sledding, or skating. Both artists re-
sponded with excitement to the activities of the park. Bellows gave this painting and
others to his roommate and fellow artist, Edward Keefe.

REFERENCES: George Bellows, "Private Book of Paintings" (unpublished ms.), v. A,
sketch on p. 19; Charles H. Morgan, George Bellows: Painter of America, New York, 1965,
p. 57; Gordon Brown, "Notes on Things American," Arts Magazine, Dec. 1967–Jan. 1968, ill.
p. 39.

EXHIBITED: Hirschl & Adler Galleries, New York, 1968, American Paintings for Public and
Private Collections, no. 92, ill.; Metropolitan Museum, 1968, New York Collects: Paintings,
Watercolors, and Sculpture from Private Collections, no. 3.

EX COLL.: Edward R. Keefe; [Hirschl & Adler Galleries, 1967].

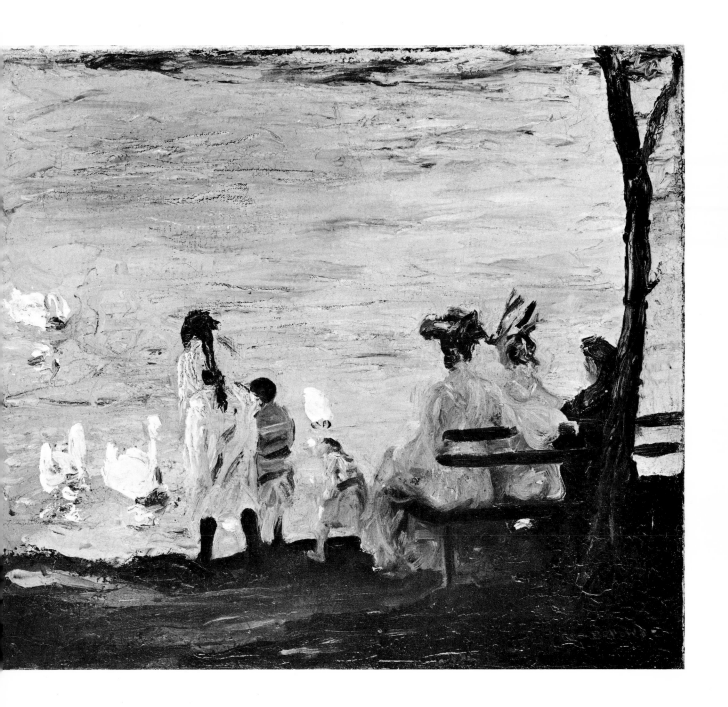

50 BELLOWS: Emma in the Purple Dress

Oil on panel; 40 x 32 inches.
Signed (lower right): Geo. Bellows; inscribed (back of panel): Emma in
the Purple Dress/painted in Middletown, Rhode Island/June, 1919.

One day in June 1919 Bellows's wife, Emma, returned from a shopping trip with
some purple silk material that perfectly complemented one of her favorite blouses.
She quickly created a long skirt to match, and Bellows was so taken by her in this
costume that he began to paint her immediately. The skirt and blouse are painted
with great gusto and freedom, and the color is rich and striking. "I think I have
painted my best portrait of Emma and a rare picture to boot. A hand and an eye,
the width of the shadow side of the head are still in question." Up to this point he
had done few single, formal portraits of Emma. His wife usually appeared in family
groups or as a figure in an interior or landscape scene. But with this portrait he
concentrated more intently on her. In July he painted another three-quarter, full-
face view of Emma in a black print dress (Museum of Fine Arts, Boston). The
following year he began a full-length, seated version of her in this same purple dress
(Dallas Museum of Fine Arts), though he did not complete it until 1923. It is bluer,
more purple in tone than the Horowitz painting. Emma is seated in both versions,
although on different chairs—here with her hands clasped, while in the other paint-
ing with her hands resting separately in her lap. Emma seems serene in the full-
length version; here she is surrounded by an air of mystery and introspection. "I be-
lieve," wrote Daniel Catton Rich, "the best of Bellows lies in those strong, simple
and almost puritanical portraits where a love of painting and the unconscious bond
between sitter and painter triumphed."

REFERENCES: George Bellows, "Private Books of Paintings" (unpublished ms.), p. 165;
College Art Association, *Index of Twentieth Century Artists*, v. I, no. 6, March 1934, p. 88;
Charles H. Morgan, *George Bellows: Painter of America*, New York, 1965, p. 225; Gordon
Allison, Telephone conversation with D. H. P., 14 Sept. 1972.

EXHIBITED: Art Institute of Chicago, 1919, *32nd Annual Exhibition of American Oil Paint-
ing and Sculpture*, no. 13, ill.; Corcoran Gallery of Art, Washington, D.C., 1919/1920, *7th
Annual Exhibition of Oil Paintings by Contemporary Artists*, no. 150 (as Portrait of Emma);
Buffalo [New York] Fine Arts Academy, Albright Art Gallery, 1920, *14th Annual Exhibition
of Selected Paintings by American Artists*, no. 7, ill. (as Emma in Purple).

EX COLL.: Emma S. Bellows estate; [H. V. Allison & Co., New York, 1971].

164

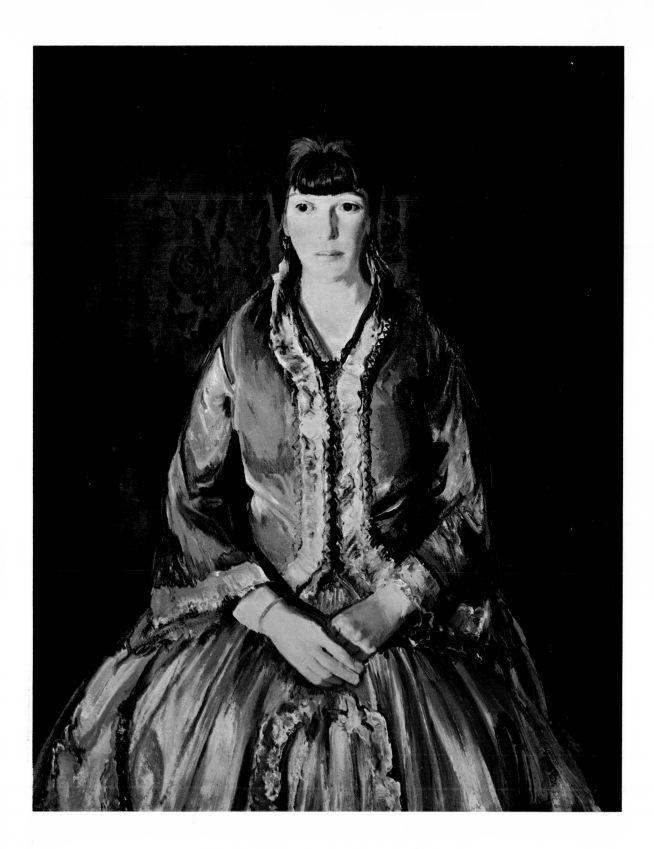

INDEX OF ARTISTS